A CELEBRATION OF LIGHT

painting the textures of light in watercolor
Jane Freeman

NORTH LIGHT BOOKS
CINCINNATI, OHIO
www.artistsnetwork.com

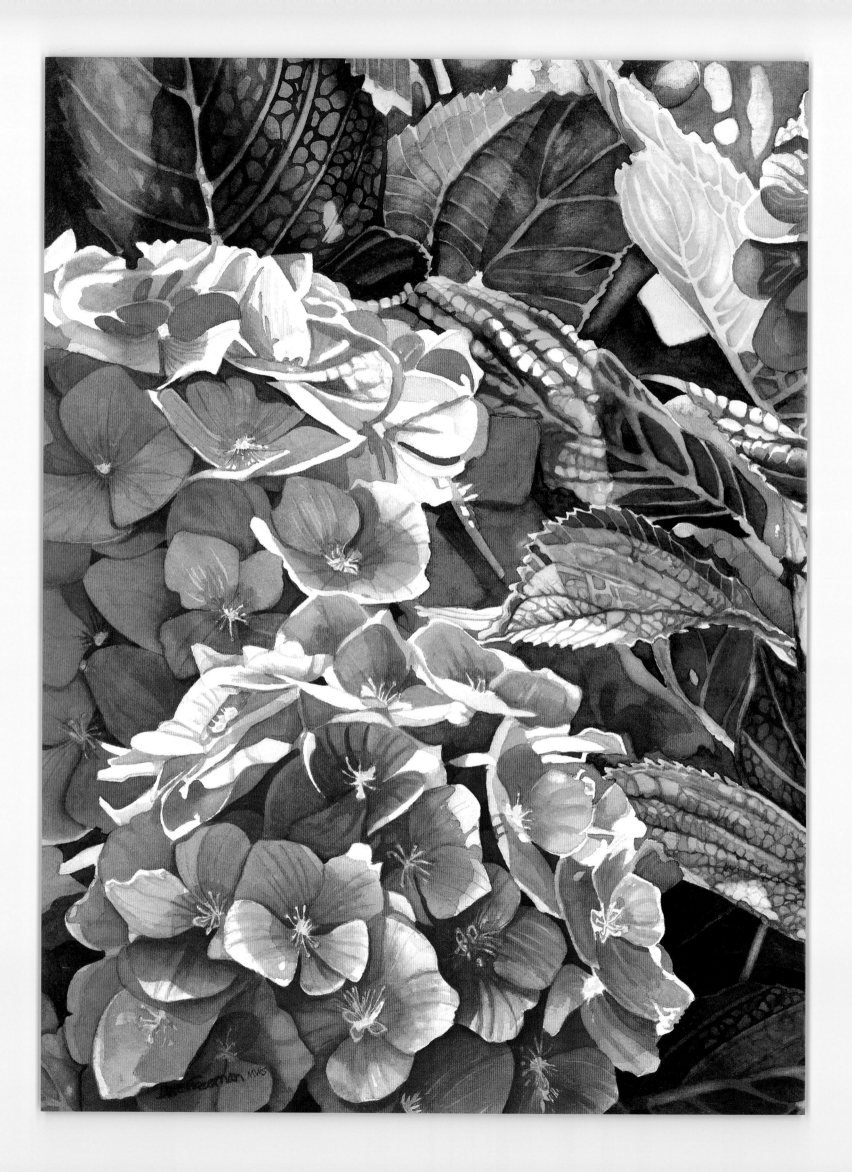

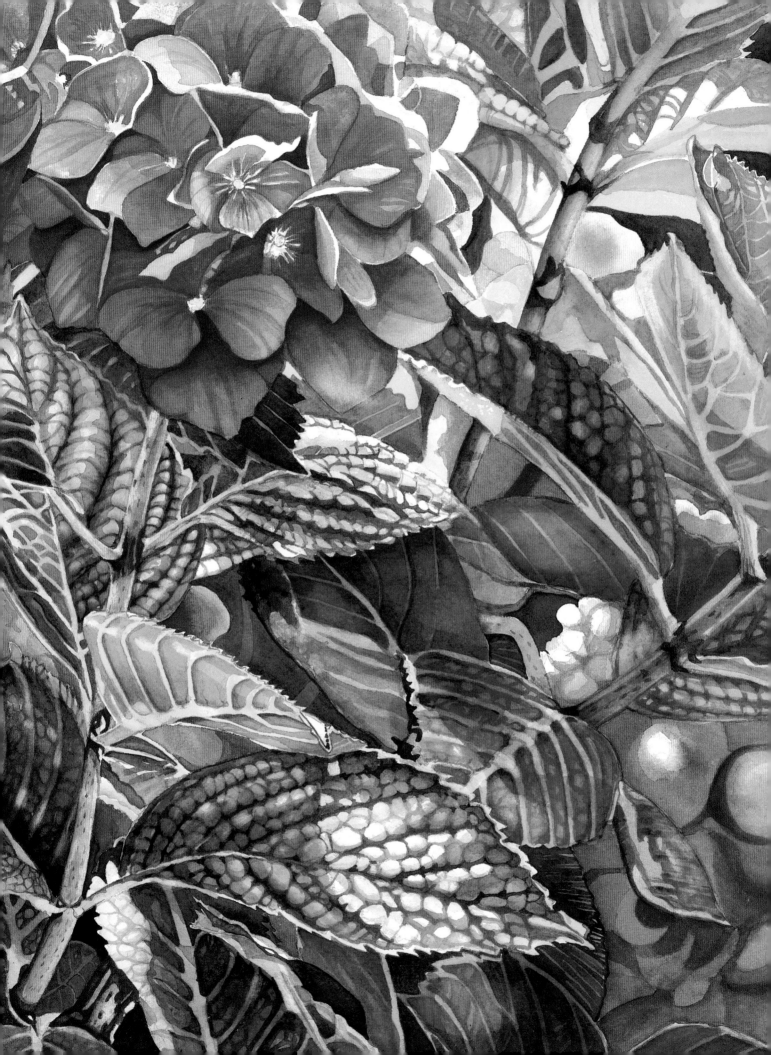

A Celebration of Light. Copyright © 2007 by Jane Freeman. Manufactured in China. All rights reserved. No part of this book may be reproduced in any form or by any electronic or mechanical means including information storage and retrieval systems without permission in writing from the publisher, except by a reviewer who may quote brief passages in a review. Published by North Light Books, an imprint of F+W Publications, Inc., 4700 East Galbraith Road, Cincinnati, Ohio, 45236. (800) 289-0963. First edition.

Other fine North Light Books are available from your local bookstore, art supply store or direct from the publisher at www.fwbookstore.com.

11 10 09 08 07 5 4 3 2 1

DISTRIBUTED IN CANADA BY FRASER DIRECT
100 Armstrong Avenue
Georgetown, ON, Canada L7G 5S4
Tel: (905) 877-4411

DISTRIBUTED IN THE U.K. AND EUROPE BY DAVID & CHARLES
Brunel House, Newton Abbot, Devon, TQ12 4PU, England
Tel: (+44) 1626 323200, Fax: (+44) 1626 323319
Email: postmaster@davidandcharles.co.uk

DISTRIBUTED IN AUSTRALIA BY CAPRICORN LINK
P.O. Box 704, S. Windsor NSW, 2756 Australia
Tel: (02) 4577-3555

Library of Congress Cataloging in Publication Data
Freeman, Jane
 A celebration of light : painting the textures of light in watercolor / by Jane Freeman. -- 1st ed.
 p. cm.
 Includes index.
 ISBN-13: 978-1-58180-873-5 (hardcover : alk. paper)
 1. Watercolor painting--Technique. 2. Light in art. I. Title.

ND2420.F74 2007
751.42'2--dc22 2007004470

Edited by Stefanie Laufersweiler
Production edited by Mary Burzlaff
Designed by Guy Kelly
Production coordinated by Matt Wagner

The permissions on page 127 constitute an extension of this copyright page.

Metric Conversion Chart

To convert	to	multiply by
Inches	Centimeters	2.54
Centimeters	Inches	0.4
Feet	Centimeters	30.5
Centimeters	Feet	0.03
Yards	Meters	0.9
Meters	Yards	1.1
Sq. Inches	Sq. Centimeters	6.45
Sq. Centimeters	Sq. Inches	0.16

About the Author

Jane Freeman was born in Williston, North Dakota, and was raised in Alamo, North Dakota, on the family cattle and wheat ranch. She began painting in high school, going on to receive a composite major/minor in art from the University of North Dakota. In addition to watercolor, she has worked in acrylics, oils, sculpture and printmaking, and she has also studied medical illustration, which nurtured her love for drawing. Jane has worked primarily in watercolor since 1989, and her art has been accepted into a number of national and international shows. She has earned signature status with the Transparent Watercolor Society of America, the Missouri Watercolor Society and the Red River Watercolor Society, and is an associate member of the American Watercolor Society, National Watercolor Society, Minnesota Watercolor Society, the Arizona Watercolor Association and Watercolor West. Jane is also a member of the International Guild of Realism.

Jane's artwork has appeared in two volumes of North Light's best-of-watercolor series, *Splash 7: A Celebration of Light* and *Splash 9: Watercolor Secrets*, and *How Did You Paint That? 100 Ways to Paint Still Life and Florals* (International Artist). She has also been featured in *American Artist*, *Watercolor* and *International Artist* magazines, and she is a past editor of the website www.artcafe.net, where she interviewed nationally known artists. Jane teaches watercolor workshops throughout the U.S. and Canada.

Jane lives in northern Minnesota with her husband, Andy, her two rescued cats, George and Gracie, and a rescued dog, Miss Millie. She has two grown children, Suzy and Luke. Visit Jane's blog at http://watercolorist.blogspot.com and her website at www.janefreeman.com.

Acknowledgments

In making a book there are so many people who step forward to help that it will be impossible for me to thank everyone. These stand out in my mind as those who walked beside me on this journey of a lifetime.

I want to first thank God for this talent and for opening doors that I never would have dared to dream of on my own. You held the brush and gave me the strength to believe I could do this.

I would like to thank Bob Smith and Steve Mortenson for helping me learn the photography required for this book. A big thanks to Giclee By The Bay for the great scans for the book.

With a grateful heart, I want to thank Jamie Markle, who asked me to write this book, and especially Stefanie Laufersweiler, for patiently helping me with the editing and organization. You were with me every step of the way, and I thank you so much for all your encouragement.

To my dear friend Margo, who gave me pep talks and massages when my back went out. Your positive outlook is an inspiration to me every day. To Carol, Sandy, Christiane and Jan, who cheered me with emails and phone calls of support and encouragement.

I wish to thank the contributing artists in this book, who were willing to jump on board with such enthusiasm. You are all such amazing artists, and I am blessed to be able to call you my friends.

Thank you to my family for checking on me and cheering my success. David and Shirley, your support and belief in me means so much. Gloria, thank you for being there, and Marlene, for cheering me on with weekly phone calls of support. Those calls meant so much. Andy, thank you for putting up with a house that was upside down for the better part of a year. I need your support every day if I am going to chase this dream.

Lastly, I would like to thank my children, Suzy and Luke, who believe in their mom and offered me encouragement on this venture. I love you both more than I can ever express, and I hope you see from my example that, even if your dreams have to be put on hold, anything is possible if you hang in there and don't give up.

Meet life with open arms, live each day to the fullest, be thankful for all the blessings and dream big!

Art on pages 2-3:

Manzanita Morning
Watercolor on cold-pressed paper
20" x 26" (51cm x 66cm)
Private collection

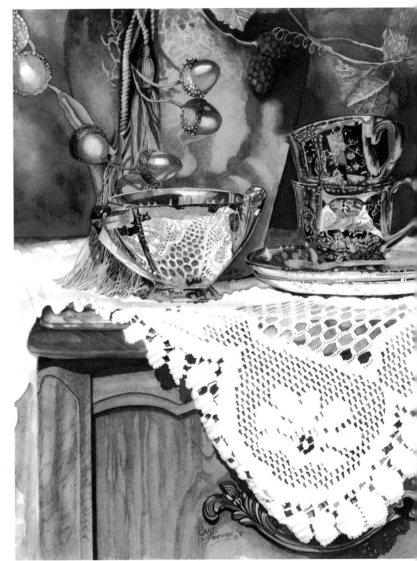

Golden Anniversary
Watercolor on cold-pressed paper
19" x 13" (48cm x 33cm)
Private collection

Dedication

I wish to thank my parents, who always asked me to get back into my art seriously and always believed in my ability to paint. They passed away before seeing my career take off, so it is to them that I dedicate this book.

Foreword

A number of years ago, Jane Freeman invited me to be featured on the Internet website, "Art Café." Jane was a strong advocate of this particular site and was often a leader in the varied discussion groups that related to various art mediums, especially transparent watercolor. It was immediately apparent that the many regulars and visitors on the site all adored Jane and her keen sense of humor, and they highly respected her remarkable ability as an artist. After this, we became "email" friends and have been communicating with one another from across the U.S. for a number of years.

It has been interesting to watch Jane blossom into one of our leading artists in the medium of transparent watercolor. Open any current, important watercolor book or magazine and you will likely see her work reproduced on its pages. Her chosen subjects have a wide range; however, the subjects of flowers and vegetables remain strong choices in her current still-life work. It is evident that she loves these particular subjects, and not only because she excels at them. One can see the love and care that she expresses about these varied, beautiful and interesting forms that are found all about us in our everyday lives.

Jane draws upon her remarkable vision in putting her still life together, visually applying her unique conceptual ability and the understanding she has of drawing, design, color and values with a well-honed painting proficiency. All of these factors are critical for success in any subject or school of art. It is apparent that Jane has this cunning sense of design, and the interesting way in which she places her objects together creates significant, beautifully resonating shapes. She knows when to be extremely intricate, but she has the self-discipline to hold back the detail when it needs to be hushed. Her shapes and colors are always well designed, and she provides a harmony in her compositions that pleases the eye.

Light also plays a strong role within her compositions, and she uses it to direct us from one object to another. Her crystal and glass objects are radiant with a lavish light that is complemented by her choices of nearby darks. Her varied uses of values not only define and hold objects together as a group, but once again, serve as visual guides for moving the eye about the composition.

Flowers are featured in Jane's paintings quite often. Floral subjects convey all kinds of wonderful, universal messages for each and every one of us, and Jane continually presents these subjects in glowing, translucent light with dramatic shadows. Sometimes they literally fill her paintings, and occasionally they seem to visually expand beyond the compositional space that contains them.

Jane's paintings are a delight to behold, and in this book, she reveals how she creates those remarkable, colorful images. Being an art professor myself for many years, I know that it requires more than just being a good teacher to create successful students. Successful students will meet the teacher halfway. They are self-motivated, possess an unrelenting curiosity, and have the desire to learn so that they can create special, meaningful graphic images to convey something extraordinary. So read and look at this book closely, dissecting the words and images that Jane puts before you—then apply yourself to the fullest. You will not be sorry.

Often it has been said that anybody can do one good painting; the secret to being a successful artist is the ability to create many good paintings and a body of work. This takes an unyielding commitment: dedicated, focused, hard work. Jane Freeman is profoundly aware of this, and her work celebrates and confirms it. However, we can also see the joy and love in her paintings.

Robert Reynolds
Artist and Professor of Art/Emeritus, Cal Poly University
Author of *Painting Nature's Peaceful Places* with Patrick Seslar
and *The Art of Robert Reynolds: Quiet Journey*

September, 2006
San Luis Obispo, California

CONTENTS

Introduction
page 8

one
Getting Started
page 10

Find the right materials—and the time and a place—
for creating your art.

two
Composing Light
page 20

Planning and painting a luminous masterpiece involves
much more than just saving the white of the paper or
working in lighter values.

three
Light and Color
page 36

Understanding basic color theory and fully realizing
the potential that rests on your palette will lead
to vibrant paintings.

four
Techniques for Painting
page 54

The control is in your hands: prime, glaze, stroke and lift
your way to more impressive watercolors.

five
Creating Backgrounds
page 70

Make a background that makes your subject
look even better.

six
Painting Practice
page 80

Put your skills to the test as you paint silver, denim,
woodgrain, crystal, flower petals, lace and more.

Index
page 126

Contributing Artists
page 127

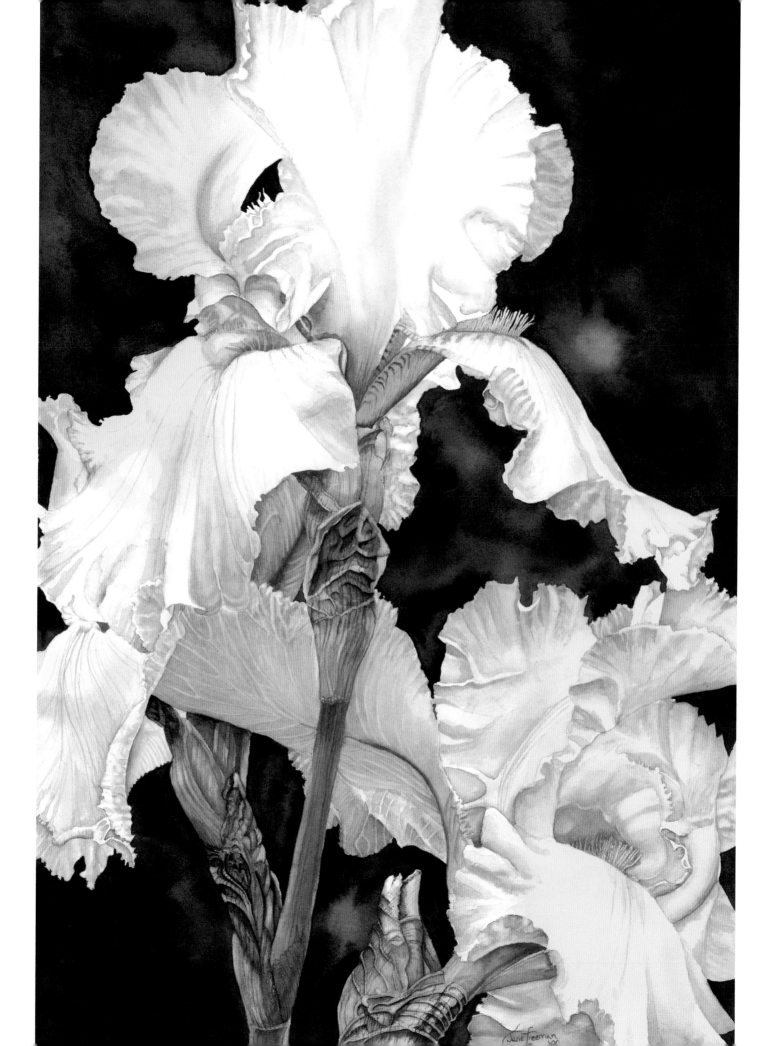

INTRODUCTION

"Ideas are to literature what light is to painting."

—Paul Bourget

When I was asked to write a book about painting light, I was scared to death, but delighted. Scared because I was not sure I could handle the tasks involved, but delighted because I would get to share with you my journey and encourage you on your own journey to finding the light!

I discovered light and understood it better by using my camera, and I hope to share some of that understanding with you. Light is evasive and moves so quickly across a subject. By capturing the light of the moment on film, you can explore what is happening and understand light more easily. Once I saw what a difference photographs made in my work, I was hooked. I still do not understand all the scientific reasons for what happens with light, but there are books that explain if you are interested, such as *Light Up Your Watercolors Layer by Layer* by Linda Stevens Moyer. For me, it was enough that I had learned to see light so I could translate it to my paper.

Light tells the viewer so much about what is happening in the moment of time that you are trying to paint: how the leaves have faded out, or how the shadows reflect the sky. The angle of the shadows can even convey the time of day. You need to relay that information so your viewer can have a better sense of what it was that inspired you to paint this subject in the first place. Often what inspires you will not be the subject so much as *what light is doing* to the subject.

Light is not easy to capture. It is ever-changing, as are the colors it produces and the reflections it causes. The light in your painting can be only as bright as your deepest shadows, because it is this contrast that creates the illusion of actual light. In this book, you will learn how to bring light into your paintings by portraying shadows.

My desire is for you to see just how easy my method of painting is, even if you have only twenty minutes to an hour a day to paint. Do not let time stop you from creating! Hopefully this method will be a springboard for you, and with each success you have, you will gain more confidence in your ability to render light.

I did not want this book to be just about my work and how I accomplish my paintings. There are so many wonderful artists today in the field of watercolor that I wanted you to see what some of them think as well. The ten contributing artists I've chosen for my book are friends whose work is similar to mine in that it is realistic, it incorporates light and shadow, and it demonstrates the importance of texture. All these artists have their own methods and their own styles of painting. They share their painting secrets on special pages throughout the book.

You will see through this book how the elements of a strong painting are the same no matter what you want to paint. I hope you will see the importance of these elements and learn how to use them to achieve a variety of effects. Somewhere amongst all the paintings you see here, I hope you begin to find a vision for your own work and a path to follow that will lead to great happiness and success.

Don't waste another year wishing you could find the time to improve your painting. Nothing ever got done by wishing. Make the decision to honor the gift that has been given to you. I believe in you—because if I can do it, you can do it!

Summer Dream
Watercolor on cold-pressed paper
22" x 14" (56cm x 36cm)

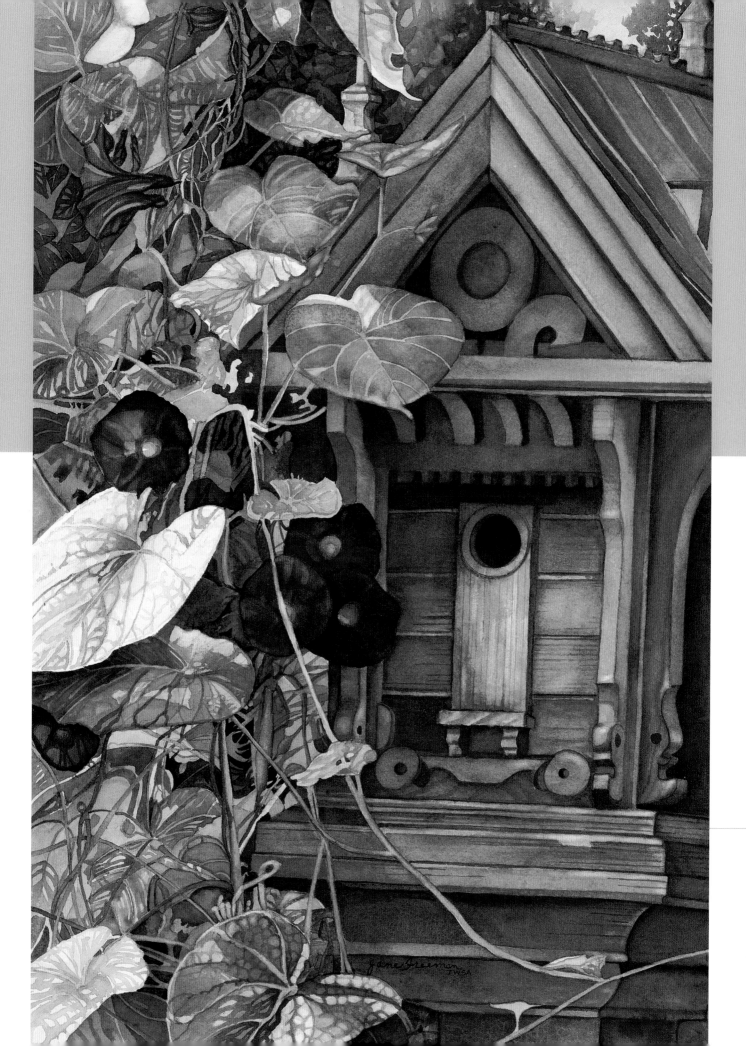

GETTING STARTED

"Do what you can,
with what you have,
where you are."

—Theodore Roosevelt

Each artist has a preference for certain paints, brushes and paper that they have become most comfortable with over time. In this chapter you are going to see what tools I'm most at ease with, and later you'll learn how to use them. As with any purchase, choose what works best for you. The supplies and brands I like may not appeal to you as much as others. By all means, experiment and buy what you like.

A Well-Painted Haven
The birdhouse was created with many layers of glazes to make the wood glow and give it a different feel from the leaves. A good drawing was the key to keeping the composition in perspective and making it feel believable and realistic.

Glorious Morning
Watercolor on cold-pressed paper
21" x 14" (53cm x 36cm)

Paper

I have regularly used 140-lb. (300gsm) cold-pressed paper, soaked for twenty minutes and stretched. You must stretch this weight of paper or it will buckle and you will be unable to get smooth washes. Soaking the paper removes the sizing, giving you a wonderful, velvety-soft and absorbent surface to work on.

You could forego stretching altogether by using heavier-weight paper. I recently switched to 300-lb. (640gsm) cold-press. An added benefit of this paper is that since the sizing has not been removed, the paint seems to sit more on the surface, which can make the paint easier to lift off. I tape the paper to a support to help keep it as flat as possible, but if many layers of paint have been applied, I often have to flatten the finished piece before framing.

Brushes

Without a good brush, painting is much harder, so get the right brushes and make life easier. Good qualities to look for in a watercolor brush:

- maintains a good point, even after hard use
- holds a good amount of water
- has a nice "spring" and is not limp as a noodle when wet (You can't do fine detail with a brush you cannot control.)

If I could have only one brush, it would be a no. 8 round. Its pointed tip can get into tight spaces, yet the brush can also cover a lot of surface area. In fact, I can complete most of my paintings using only no. 8 and no. 24 rounds.

Various types and sizes are helpful to have handy, however. (See my must-haves pictured on this page.) Brands that I've come to love, mainly because their brushes maintain fairly good points, are: Loew-Cornell, Daniel Smith, Black Gold by Dynasty, Robert Simmons and Jack Richeson. I prefer synthetic brushes, because I've found that they can possess all of the qualities I seek in a good brush and are relatively inexpensive. As with any painting materials, experiment to see where your preferences lie.

wash or hake (large areas)

rounds (washes, details)

scrubbers (lifting)

old toothbrush (lifting)

soft housepainter (erasure cleanup)

Demonstration Brushes

These brushes were used to complete the demonstrations in this book.
- round nos. 2, 4, 6, 8, 10, 24, 36
- assorted small scrubber brushes, including a round and a flat
- 2-inch (51mm) flat wash or hake
- old toothbrush

So Long to Standard Stretching

A special stretching board available at www.watercolorboard.com makes stretching your paper a breeze. After soaking your paper, lay it on the board, then secure the edges of the paper under a metal frame using screws. Then simply let the paper dry and start painting. After you've finished, simply remove the artwork from the board and cut off the indentation left around the edges by the metal frame before you do the final framing. Visit the website for more information.

Paints

I've used Daniel Smith watercolors almost exclusively for several years. They offer a broad range of clean colors, and the catalog clearly lists the properties of each pigment. (These properties are explored further in chapter three.) This information isn't always listed in other catalogs. Also, perhaps because it is a smaller company, I can call and speak to someone directly who can answer my questions about the paints. I've become interested in M. Graham & Co. paints as well, for similar reasons: the colors are bright and clean, and I can call and speak to someone directly.

See the sidebar for the specific colors used for the demonstrations in this book. Feel free to substitute your own colors, but be aware that the appearance and characteristics of paints can vary from brand to brand—and that goes even for colors that share the same name.

Other Must-Haves

A palette. Make sure it has large wells and sizable mixing areas. I use a John Pike plastic palette that is now seventeen years old and still going strong.

A workspace. A table offers a flat surface to work on and to hold brushes, a palette and water. When you want to work on an angle, prop up one end of your painting with a few books, or rest it on a Styrofoam wedge cut to a 45-degree angle. You'll also want easily accessible storage for your supplies.

Lights. I use Ott lights, as they can clamp onto your work table and come with a magnifying glass. Ott also makes a folding lamp that is great for small spaces.

Gator board. This lightweight support allows you to move your painting around with ease.

Staples and tape. Use staples with artist's tape or other specialty tape to hold the paper in place on your support. The tape should lift easily without tearing the paper. Low Tack Artist Tape by 3M Scotch works especially well for this; check your local hardware store.

Graphite pencils. The pencils you draw with on your watercolor paper can range from a 2B to a 2HB, but a middle-of-the-road HB pencil (the yellow school kind) will save you money and do the job just as well.

Erasers. I use the kneaded kind to remove some of the graphite from my drawing before painting. I prefer a white plas-

tic eraser (such as Sanford's Magic Rub) to remove final pencil lines in light areas.

Water container. Use small white or clear containers. They allow you to easily see when the water is getting dirty, so you will change your water more often and prevent muddy washes.

Demonstration Palette

These watercolors were used to complete the demonstrations in this book. They are Daniel Smith paints unless otherwise indicated.

Violets
Carbazole Violet • Moonglow • Naphthamide Maroon • Permanent Violet • Raw Umber Violet

Blues
Cobalt Teal Blue • French Ultramarine • Indanthrone Blue • Indigo • Manganese Blue Hue • Neutral Tint (M. Graham & Co.) • Payne's Gray • Phthalo Blue (Green Shade) • Phthalo Turquoise • Vivianite (Blue Ochre)

Greens
Phthalo Green (Blue Shade) • Sap Green • Undersea Green

Yellows
Aureolin (Cobalt Yellow) • French Ochre • New Gamboge • Quinacridone Gold

Reds
Anthraquinoid Red • Naphthol Red (M. Graham & Co.) • Perylene Red • Perylene Scarlet • Pyrrol Crimson • Pyrrol Orange • Quinacridone Fuchsia • Quinacridone Rose

Browns
Burnt Sienna • Goethite (Brown Ochre) • Hematite • Lunar Earth • Permanent Brown • Quinacridone Burnt Orange • Quinacridone Burnt Scarlet • Quinacridone Sienna • Transparent Brown Oxide

Porcelain Dishes

Keep these beside your palette for holding large amounts of paint when you mix colors for a painting. This is especially handy to ensure you do not have to mix more mid-painting, when you may not recall how you mixed it. These dishes also work great for coating stamps evenly before applying them to your paper.

Value Scale

Keep your values correct as you work by using a gray value scale. You'll need two identical scales with holes punched in them to look through: one scale to hold over your reference photo, and one for your painting. This way you can compare values to see if they are the same. I never duplicate things just as they appear in a photo, but this tool helps you isolate the various shades in your scene to determine what is dark or light, and how you want to translate, change or emphasize this in your painting. You can buy these scales or make your own.

Gray Markers

You can use 20 percent and 40 percent Warm Gray Prismacolor Four-in-One Markers on black-and-white photocopies to see how darkening areas or adding shadows might create better contrast and strengthen a composition. Darkening areas can help you decide if pushing something back in your picture will enhance your center of interest. You can determine how to darken the folds of fabrics to give them more definition, or see if casting a shadow or darkening one will work. It's a great way to try something out without being committed. If it works, you can then incorporate it into your painting. I used to do this in pencil until fellow artist Judy Morris told me about these markers, and it is so much easier. I have many photocopies printed at once so I can experiment with as many different variations as I want.

Masking Fluid

I don't make a habit of using masking fluid—I prefer to paint around my whites—but I sometimes use a Masquepen to protect fine lines that otherwise would be hard to save.

Coarse Salt

I've played with Morton Kosher salt to create texture in the paint.

Stamps, Stencils and Contact Shelf Paper

I'm just beginning to experiment with stamps and stencils. They can add great texture and interest, so I am trying to incorporate them into a few of my own paintings (see page 65). You can buy stamps and stencils at most craft and art stores or make your own. Contact shelf paper can be used to protect parts of the painting when applying stencils or stamps to nearby areas.

Acrylics

Acrylics can be used to recover that fine line, detail or highlight lost in the process of painting. An advantage to using acrylics for this is that they will not look chalky like watercolor gouache. However, bear in mind that adding any media other than watercolor to a painting will disqualify it from most watercolor competitions.

I prefer Golden fluid acrylics because they come in small bottles, are already in liquid form and can be diluted to a watercolorlike consistency. Since I use it only to recover a lost white now and then, I don't want tubes that will dry out. I use Titanium White for whites I've lost or failed to save. I've also used Jo Sonja's acrylic gouache to add highlights or correct mistakes. If you mess up a large background, for example, a few light washes of this gouache can help even things out. (Phthalo Blue and Warm White are used in the demonstration that begins on page 102.)

FINDING TIME AND A PLACE FOR YOUR ART

Add Art to Your Juggling Act

The question I hear most often is, "How do I find time for my art?" Day jobs, obligations and everyday life can lead us to push art to the back burner. For parents in particular, it's a juggling act to get the kids to school, sports practice and piano lessons while making meals, cleaning the house, running errands or working 9 to 5. Parents often give to everyone else and neglect their own needs. We might even feel guilty for spending valuable time on ourselves.

If you find joy in painting, you are actually doing a disservice not only to yourself but to those around you by *not* painting or drawing. You could be a happier, more emotionally balanced individual and spouse, parent, grandparent or friend if you make it a priority to feed your soul as well. So, now the trick is fitting time to enjoy your art into your schedule.

Keep Your Supplies Within Reach

Part of the trick to finding time for art is having your painting supplies conveniently placed so you can just walk up to them and use them. Not every artist is lucky enough to have studio space devoted solely to creative pursuits. But there are other ways to keep your supplies close at hand and ready for use without cluttering areas of your home. Check out some of the work and storage suggestions shown on the next page.

Paint for Minutes When You Can't Find Hours

Many artists will tell you that you have to paint for hours a day if you want to be good, or that you have to paint one hundred bad paintings before you get one right. These myths keep many from painting, because how can anyone with responsibilities find that much time—let alone that many sheets of watercolor paper?

Consider this: working twenty minutes a day, five days a week will amount to about eighty hours of painting in one year. That is amazing and well worth it, don't you think? If I had done this, I would have logged 1,200 hours of painting during fifteen years of getting the kids through grade school! Instead, I thought twenty minutes a day was not enough time, and I gave up. When I finally tried it, it took an entire winter to complete a painting, but that painting—*Summer Dream* (page 8)—was juried into the American Watercolor Society and chosen for *Splash 7*, a book featuring the winners of a best-of-watercolor competition. What more could you ask for? This works!

Find those moments in the day when you can work on your art, even if it is only for short increments. It will satisfy your artistic needs, which will enrich your life and give you greater joy. Plus, you'll keep your skills honed so that when you do have

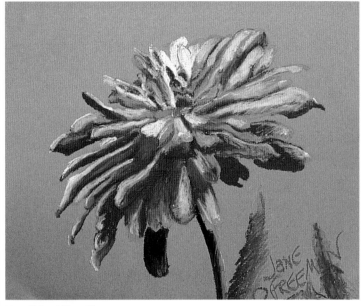

Use What You Have
Over twenty-five years ago, when my kids were young and we were short on money, I drew this with crayon on a brown paper bag. I used what I had to keep creating. I hang it where I can see it often to remind myself that I have a dream. It helps me stay on track and remember that anything is possible if we believe in ourselves.

more time to paint, you will not have to spend time relearning. You will be miles ahead of the game and have the confidence to take your art to any level you desire.

Use Techniques That Allow for Frequent Starting and Stopping

The common thread among all my painting techniques is that they allow you to stop and start frequently as you work on a painting without adversely affecting the finished product. Wet only the area of the painting that you want to work on, then paint it and work on another area later. Begin with a layer of light values, then come back tomorrow and add another layer to create medium values. Add the darkest values another day. Working in this way will not only allow you to take full advantage of short spurts of time, but will give you the time you might need away from your painting to gain new perspective on it or to solve a lingering problem.

Don't let a lack of studio space prevent you from pursuing your art. With a little creative thinking, many spaces in your home can be transformed into studio or supply storage space whenever you need it.

I know many published artists who paint in a spare bedroom or dining area, or who have devoted a corner of the basement to a studio. It is nice to have a large studio but certainly not essential, and a lack of space will not prevent you from becoming a better artist. Don't let a lack of space be your excuse for not painting.

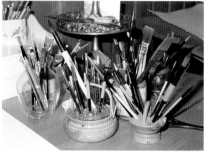

Vases and antique "frogs" store brushes in an orderly and convenient way.

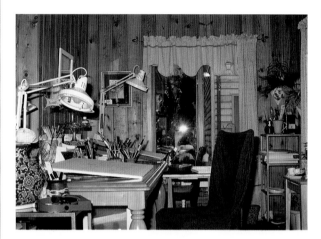

My Studio

My formal dining room is perfect for my art needs. Wonderful light pours in from all the windows, which overlook my gardens and the lake. The tile floor is studio-friendly, and being so close to the kitchen means I can paint and cook at the same time! Recently I bought a six-foot (1.8m) table to accompany my old drafting table. Now I can easily have two pieces going at once, or a drawing on the drafting table and a painting on the other one. Imagine the delivery man's surprise when asked to set up a huge dining table with just one chair!

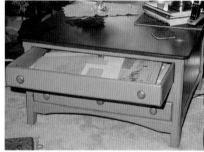

Double-Duty Furniture

If you're strapped for space, store supplies inside or even under a table with a tablecloth. A sofa table also provides a great workspace that you don't necessarily have to dismantle at the end of the day. Set it up with an attractive but functional work light and place your brushes in pretty vases so the area still looks nice and you're not tempted to take it down when company arrives.

Perfect Paper Storage

Finding a flat place to conveniently store large sheets of watercolor, drawing and tracing paper can seem impossible, especially to those who live in small spaces. I found the answer in a coffee table with roomy drawers. This multifunctional piece of furniture sits in the middle of my living room.

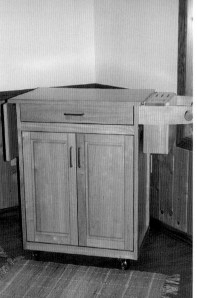

A Studio on Wheels

A rolling kitchen utility cart makes a great makeshift studio. My friend Shirley uses this for her painting area, and everything fits below when she is not painting. If you have small children or grandchildren—or just want to move it out of sight temporarily—you can roll this into a closet and lock the door. Some paints can be harmful, so keeping them away from small, curious hands is necessary. Once the kids are older, you will be able to leave your paints out and expand your area for painting, but this small cart can keep your fingers in the paint until then.

Because I try to portray light at a specific time, I rely on reference photos to capture the moment. I paint almost exclusively from my photos. Sometimes you may need to actually hold the lace or teacup to understand some of the details when working on a still life, so I keep such items accessible; but usually my reference photos show most of what I need.

Make Your Photos Do More

Let your camera help you spot the subject's most interesting elements. When you take a photo, you begin to clarify what you want to paint by isolating your subject from everything else around it. Any magnification that occurs when you zoom in will further clarify your center of interest. You can frame the subject in the viewfinder but still move your camera around to find the best composition. As you do this, you'll see interesting shapes that you didn't notice before, which can make a stronger painting.

Treat your camera as a time-saving device. My camera has become my sketchbook these days because of time constraints. It is what I use to do most of my composing and cropping. Preliminary sketches are still enormously helpful, but taking countless photos that you can play with to nail down possibilities before you move on to sketching will save you valuable planning time.

Use your camera to preserve paintable moments and scenes that won't last. I love to paint flowers, but living in northern Minnesota means I have them in my garden only from June to September. I began using photos about ten years ago because they let me paint my flowers even in the dead of winter. I also depend on photos for my still-life setups. I like to do my setups in a window with natural light, but where I live, we can have lengthy periods without sunshine. So, on a sunny day, I arrange everything I own in my windows all day long and take photos. That is a day well spent, because I will have material ready for all those rainy days. Be sure to capture seasonal details, trip scenes, fleeting moments and once-in-a-lifetime opportunities on film.

Gather the Information You Need

Photograph a scene in parts as well as in full. Take as many photos as you can. After you've taken full-shot photos of your scene, stay in the exact same spot and zoom in to photograph the scene in parts. Later you'll be able to piece these together and overlap them to make a large picture containing the details you'll need to make a fairly accurate painting.

Decode every detail of your scene. How often have you thought a photo looked great compositionally, but some areas were confusing because you couldn't really see what was happening? This common problem tends to transfer to your paintings and confuse viewers as well. Take plenty of close-up photos to give you all the information about your subject: a fabric's folds, a

leaf's veins, a fender's rust—whatever intricate or complex areas that could confound you later as you paint. You might not plan on clearly detailing every square inch of your painting, but you'll have the option of adding detail wherever you want it, and a solid reference to work from.

Vary your viewpoint. Take many photos from multiple angles to discover the angle that works best for that particular subject. A different perspective or unusual viewpoint could be the perfect solution to create an interesting painting. Look down or up at your subject. Move from side to side to vary the angle from which the light hits your subject and discover the shadows this creates. These shadows can add interest, give objects a foundation, become directional lines and unite elements of your subject.

Whenever possible, choose setups that you can easily recreate. Try using items from your home so you can reconstruct most of the setup later if you need more information, or so you can refer back to a specific item.

Optimize Light and Shadow in Your Shots

Turn up the contrast in your photos to set the stage for dramatic paintings. Without nice shadows to start with, you'll have a very flat photo and nothing much of interest to paint later. Cast

The Sum of Its Parts
Photograph every part of the subject, not just the whole. Piecing together and overlapping these shots will offer a more complete reference not only for the scene's overall composition but for all the details.

shadows and reflections tell a story about the scene's time of day and give a painting more interest. Having dark shadows next to light, bright areas will make those areas of your subject pop and become exciting. Having both deep darks and bright whites also helps to give you a full range of values, which can take your work from dull to dramatic.

See how different times of day affect your subject. Leave a still-life setup near a window for several days and watch how the sunlight plays off everything as time passes. When you see something about your subject that makes you look twice because it is so beautiful, note the time and ask yourself just what it is that makes the moment so exceptional.

Discover your favorite times to get shots. Light tells part of the story of your painting, so note the times when the natural light you have to work with is most beautiful and appropriate for your compositions. Have your camera ready so that when the lighting is right, you can capture it. Mornings offer soft light and shadows, whereas late afternoons present long, dark, dramatic shadows. Midday light is very direct and intense.

Notice how the seasons affect the natural light falling on your subject. This goes for still-life setups inside as well as location shots outside. Both winter and summer have their bright, sunny days, but light bouncing off snow can create an entirely different, unique look when it hits your subject.

Know what lurks in the shadows. Zoom in and take shots that reveal what is really there. If you were to paint an area as just dark and flat, it might appear to be a hole when it actually may be an object or group of objects that are just covered in shadow. By painting the detail that is there first and then painting the shadows over it, you will achieve interest in what would otherwise

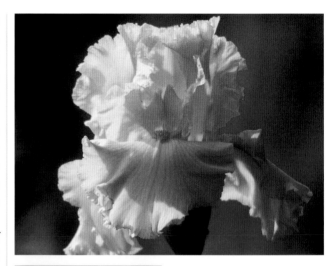

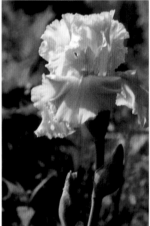

Gather Complete Information
I took a closeup from exactly the same angle as the full-flower shot to capture the curl of the front petal and the detail in the center of the iris. Now I have all the information I should need to paint this iris correctly. Additional closeups of the most confusing areas—shadows and other darks—will save me from potentially art-ruining guesswork as well.

be just a dead space. This clarification allows you to tell the whole story and make your painting much more believable.

Create more light with the help of mirrors. I have never found the need to use artificial lighting, but if I need extra light, I will use a mirror to help bounce the natural light onto my subjects.

Salvage so-so shots with the help of your computer or a photo developer. If your pictures come back and you can't see certain areas very well, ask your developer to lighten them. You can also use photo-manipulation software such as Adobe® Photoshop® to enlarge the area and lighten it yourself to find out what is really there. This may also show you what is happening in the transitional space between light and dark. Sometimes the change is gradual; other times it is sharp. Color transitions from warm to cool can be revealed as well.

Storing Your Photos
Become a photo pack rat. I have so many photos stored now that it would take several lifetimes to paint what I've already photographed, but I will continue to shoot photos until I am

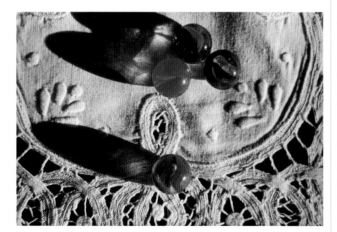

Capture the Moment That Catches Your Eye the Most
Dark, long shadows extending from these perfectly round marbles creates a stronger design element than more subtle shadows. I waited for low sunlight to shoot this picture.

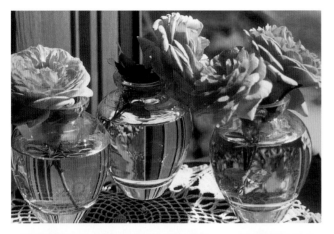

Use Closeups to Test Cropping Possibilities

I loved this arrangement, but knew there would be a lot of information inside these vases that could be confusing, so I shot many closeups. They showed more clearly what was in the dark areas and in the water. I could see all the bubbles in the water and clearly understand all the refracted shapes being reflected in the glass. Taking closeups also helps you judge if cropping would make a better painting. A more intimate look could result in a stronger composition. Your close-up photos will tell you up front if this is a possibility.

unable to paint. It is a creative process I really enjoy, and it gets me excited about the next painting. Make room for all the photos you can manage to take.

Store your photos for easy finding and refiling. Organize them by subject into easily accessible boxes. That makes it easy to just pull a box, sit down and spread it all out to see what you have.

Consider printing your digital photos instead of storing them on your computer or CD. You might be more likely to search through a box than to click your way through a collection. It just depends on how often you want to work on your computer. Personally, I prefer viewing prints rather than digital images. I enjoy handling and arranging these photos and seeing a painting come together in this way.

"A glimmer of light cannot truly be seen without much that is dark, and darkness cannot truly be felt without shadowy forms rising from the blackness."

—Anonymous

COMPOSING LIGHT

Capturing that elusive luminous quality is the ultimate goal of every watercolorist. Accomplishing this requires some thought and planning. Composing a light-filled painting involves more than just saving the whites of the paper or painting with lighter colors. Many factors are involved. Darks must be placed properly (and made dark enough) to draw attention to the light areas. Shadows must make sense. Values, contrasts and temperatures all come into play to create the sensation of light in a painting.

As an artist, you have the power to make an ordinary scene extraordinary. You can manipulate the light and shadow in your references for subtle or dramatic effect. Once you learn how, you will see your work become more exciting and inviting than it has ever been before.

Sunshine on Silver
This painting is successful because of the light and color reflected in the tray. The silver reflects the sunny sky above and the hues of the tomatoes, making it more interesting. I captured this unique lightplay by taking my shots while standing on a ladder above the outdoor setup.

Sterling Tomatoes
Watercolor on cold-pressed paper
14" x 19" (36cm x 48cm)
Collection of the artist

WHAT MAKES A STRONG COMPOSITION?

Watercolorist Adele Earnshaw once said, "A well-composed painting will work even if it's painted with shoe polish." You can paint with the finest materials and technique, but if the composition is poor, it will be a poor painting.

Light isn't always the problem in a painting, but it's likely to be one of them. If the composition of one of my paintings is off, I can pretty much count on one or more of the following elements being weak, or missing altogether. Good compositions have:

A definite light source. Reference photos without this tend to turn into bad paintings. Strong light adds depth and drama to a painting. Good shadows can give interest to a subject that would otherwise be ordinary. But, subtle light can also be effective if well executed.

Good contrast and a full range of values. Many artists make the mistake of thinking that a light-filled painting will result if they paint with only middle-to-light values. But without any darks to contrast with and showcase the light areas, all you have is a washed-out image without any sparkle. This is where a value scale comes in very handy, to ensure you're using a full range.

A well-emphasized center of interest. Save your greatest contrasts for your focal point—lightest light next to darkest dark, complement against complement, warm beside cool. These contrasts can be manipulated to attract the eye to exactly what you want the viewer to see.

A well-placed center of interest. The Golden Mean, also known as the Rule of Thirds, is one tool you can use to place your focal point in an effective location. Divide your painting into thirds horizontally and vertically—think "tic-tac-toe" grid—and wherever the lines intersect, or near those points, is where your center of interest will work the best. Generally, avoid placing your focal point dead-center or too close to the edges, where you run the risk of leading your viewer right out of the painting.

Interesting, effectively arranged shapes. This refers to not only the shapes that make up the subject, but the negative shapes around the subject, which are just as important. The lines and shapes should flow in a pattern that moves the eye. Vary the types and sizes of the shapes, but always make sure they add to, not detract from, your center of interest. Also consider the shapes created by shadows or overlapping subjects. Shadows can unify a painting that would otherwise be disjointed. Long shadows can make nice connectors between objects and create some interesting shapes in themselves. Overlapping shapes are also more appealing (and more believable) than those that line up. Edges that disappear and reappear, and the varied spaces created by overlapping objects, keep the eye engaged.

Repetition of shape and/or color. This brings a unity and rhythm that strengthens a painting. A row of teacups, for instance,

1 The distant melon adds a third circular shape; odd amounts are more eye-pleasing than even ones.

2 Long, thin shapes repeat (onion roots, tassels and basket).

3 The dotted lines are more defined as they near the focal-point onions.

4 The varied, softened peel lines gently guide the eye to the onion tops.

5 Repeating the tablecloth's green on the skins unifies the two areas.

6 The tops and the meeting point of the onions are attractively off-center.

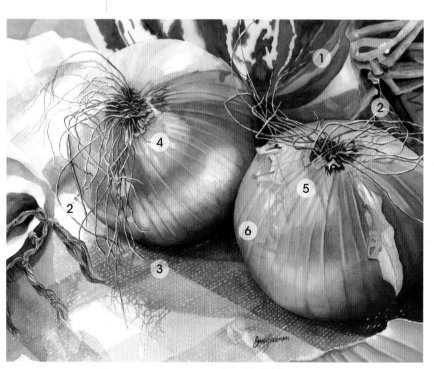

Spanish Gold
Watercolor on cold-pressed paper
14" x 19" (36cm x 48cm)
Collection of Mr. and Mrs. Tom Myers

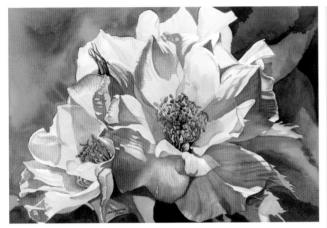

can be very interesting because the repetition of shape creates a rhythm. Repeating a color used for the subject in surrounding areas or shadows creates a unity and a rhythm as well, leading the eye around the painting and toward the center of interest.

A suitable, supportive background. This can be just as important as deciding where to put your center of interest. Sometimes the most effective background is just a dark area that can make everything else pop, and other times adding texture and pattern to that area will add interest and offer more information about the subject. Treat the background as integral to your painting's success.

Interesting Negative Shapes

With a single subject it is even more important to vary the negative spaces around the object. *Aglow* actually shows two roses, but they overlap and function more like one. All the shapes surrounding the roses are different in size and have interesting edges. Also, some parts of the flowers reach or go off the edges of the paper so the subject doesn't "float."

Aglow
Watercolor on cold-pressed paper
14" x 20" (36cm x 51cm)

1 A shadow connects and grounds the eggs so that they don't "float."

2 The lace holes (negative shapes) vary in size and shape for interest.

3 The rhythmic lace pattern carries the eye around the painting.

4 The only true whites are on the focal point: the eggs.

5 Well-placed darks and shadows ensure the busy lace won't compete with the eggs.

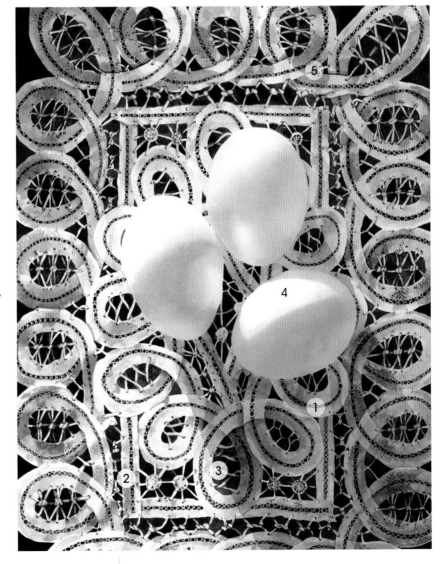

Eggsactly Right
Watercolor on cold-pressed paper
19" x 15" (48cm x 38cm)

PLANNING AND PAINTING THE LIGHTS AND DARKS

Light is that elusive quality that, if captured at the perfect moment, can be exciting and dramatic or subtly moving. In a painting, it is often the shadows that indicate where the light is. Shadows that define shapes and create patterns for the eye to follow give a painting depth and a sense of realism.

Not every painting needs to contain sharp contrasts between dark and light to be successful, however. A quiet mood may call for more subtle light. How dramatic you want your shadows to be depends on the mood you want to create and what you want to say about your subject. Whichever lighting you use, it is most important to portray enough shadow to convey the roundness or form of your subject.

Tips

Stop the problem at the source. When I look at a scene, flower or still life to photograph as a reference, if there is no light or shadow that strikes me, I usually don't bother to take the picture unless it provides information that I could use as a background or detail in another picture. That being said…

Realize that photos can reveal wonderful surprises not seen through the camera lens. Be on the lookout for unexpected areas of bounced color, intriguing shadows or unusual light effects that you didn't notice when you took the picture. Colors and shapes may occur that would be far more interesting than any effect you could imagine. Such shadows or patterns of dancing light add that extra zest to a painting that takes it out of the ordinary into the extraordinary.

When you become excited about what you see and want to paint, discover exactly what is causing this excitement. Is it the reflecting color in an unexpected place? Is the subtle glow coming from behind or under the subject more interesting than other more obvious areas of light? Whatever that "wow" factor is that made you stop and look at the scene is what you need to capture.

Use light to create shadows not only in the focal areas but in the ho-hum spots. This can add strength, form and texture to areas that otherwise would be boring.

Recognize how the patterns of light and dark guide the eye through your painting. The patterns set up by light and dark shapes, including shadows, can serve as strong compositional elements to unify the painting. Seeing and evaluating these patterns may be easier if you view your painting upside down or in a mirror. You could use markers on photocopies to test darkening an area to see if it will enhance or detract from the overall image. Also, make sure that these shapes do not direct the eye out of the painting, but rather lead the eye in.

Don't skimp on the number of values you use. Too few values will result in a very flat-looking painting. Even when you have a very well-lit subject in direct sun with few cast shadows, you'll want to add darks in some form. A scene that is too evenly lit can be boring because it lacks contrasting values.

Place the greatest value contrast near the center of interest, but also adjust the values leading to that spot. Gradually increase the value contrast as the values approach the point where you want your viewer's eye to go.

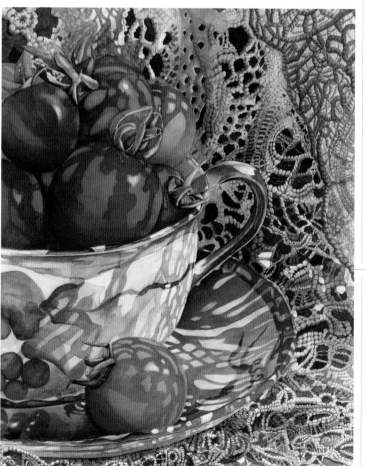

An Enlightening Moment
The first time I realized I could manipulate light to add excitement to a composition, I was setting up *Tomato Party*. As I was taking photos, I decided to add a lace curtain for some background information. As I played with the lace, the lace shadows appeared over the tomatoes.

Tomato Party
Watercolor on cold-pressed paper
19" x 15" (48cm x 38cm)
Collection of the artist

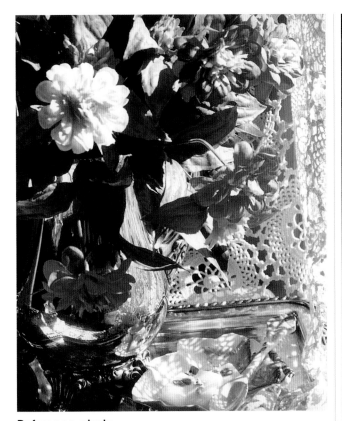

Reference photo

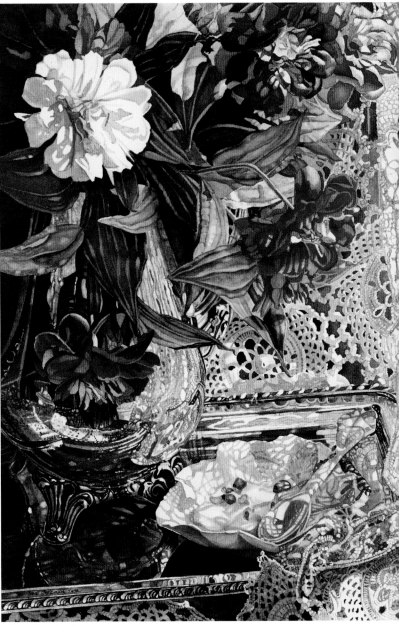

How the Direction of Light Affects Your Subject

- **Light coming from behind the subject** will pass through a transparent or translucent object such as glass or a flower, creating a luminous glow from within. If the subject is solid or opaque, the light will be blocked.

- **Light coming from the side** produces elongated shadows that can connect the objects in your scene. Side light can also cast shadows over objects, causing a textured effect that can be very interesting. Think of the cast shadows of a lace curtain across the top of a table or tomato.

- **Light coming from the front** and hitting your subject straight on causes the edges away from the light to fall into shadow. This angle can produce some dramatic effects. The more darks you introduce, the more startling your lights will become, and the more eye-catching your painting will be—if that is your goal.

Broad Value Range for High Drama

Paintings as dramatically lit as this one will contain high contrast and all ten values of the value scale. Images such as this usually command more attention because of the visual excitement all the darks and lights create.

Zelda's Zinnias
Watercolor on cold-pressed paper
20" x 13" (51cm x 33cm)
Collection of the artist

GETTING THE MOST FROM YOUR REFERENCE PHOTOS

A good photo doesn't always lead to a great painting. More often than not, you will need to make adjustments. Answering the following questions before you begin to draw and paint ensures greater success, and you will not have as many moments of "I wish I had" when you view your final painting.

Know Your Subject to Ensure Fitting Details

Ants are vital to maintaining the health of peonies. People ask for this print by saying, "I want the ant painting," as if there is no flower in it! So, I know how important that tiny creature is to its success. The small details are often what make a painting personal and believable to the viewer, but they may not always show up in your reference photos. This ant did!

Summer Home
Watercolor on cold-pressed paper
14" x 22" (36cm x 56cm)
Collection of Jane Welle

1. **Do you like the photo (or photos) before you?** You should be just itching to paint it! Excitement for your subject will fuel your enthusiasm as you paint. Don't overlook your zoomed-in photos, as they can take on an abstract nature that is interesting to paint.

 Generally, I work from one or two photos to create a painting. Over time, I've gotten the arrangement of my setups and photography down so that I can count on the photos turning out fairly well. I usually can get what I want without needing to combine many photos. You may find you need to combine more photos until you get better at photography.

2. **Will what you see in your reference look as good in a larger format?** If necessary, project the photo to see if it still has the potential to make a strong painting. What looks fantastic in a small photo may not be so appealing or compositionally strong when enlarged to the size you wish to paint it. Projecting your photos will also help problem areas become more obvious.

3. **Will cropping strengthen the image?** Move a viewfinder or a mat over your photo or an enlarged photocopy to see if cropping or deleting areas will improve it. Can this become a stronger painting by focusing on a smaller area? Also try out different proportions within your viewfinder or mat area.

4. **Do you need to add or move some elements?** Cut and paste black-and-white enlarged photocopies so you can manipulate and move around some of the elements. Create a collage with parts of another photo to produce a modified image containing the elements you are thinking of.

5. **Where is your center of interest?** Use the Golden Mean. Laying a tic-tac-toe grid over your picture will help, as you can move it around and make sure your center of interest isn't placed boringly dead-center.

6. **Do you have interesting shapes?** Evaluate the positive shapes as well as the negative spaces surrounding them. Notice where shapes need to be added, omitted, developed or simplified.

Use Prismacolor markers on black-and-white copies of your reference photo to test where you want your darks and how dark you want them to be.

7. **Do you have enough information to make this work?** Remember, the viewer will be standing in front of a much larger version of the photo. The areas closest to the viewer need to contain enough information, especially those that will lead to your center of interest.

8. **Is there a full range of values, with good contrast near the center of interest?** Use a value scale to see if you have eight to ten values. Oftentimes when a painting looks flat rather than voluminous and luminous, not enough values are present. Plan where you must save the whites and place your darkest values to bring areas forward or set areas back. Make the value contrast most noticeable at the focal point. Above all, remember that you can't portray light without the darks.

Combine References With Care

My fuchsia reference photo was good, but I added the hummingbird from another photo to create a center of interest. It's important to position added elements such as this in a way that looks natural. I have many pictures of hummingbirds as they visit my feeders, so I picked one with the right profile for the painting.

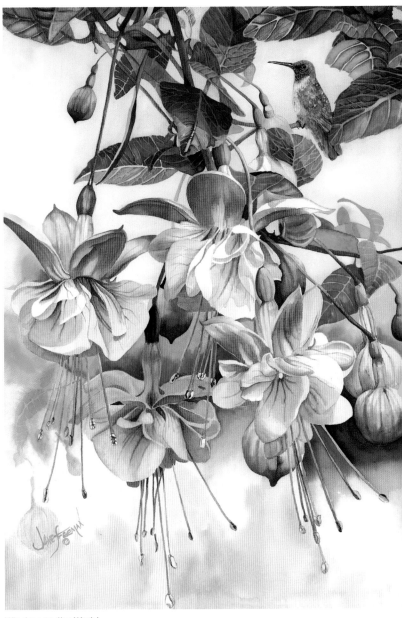

Window on the World
Watercolor on cold-pressed paper
29" x 21" (74cm x 53cm)
Collection of David and Shirley Hagen

Compositional issues should be addressed in the drawing stage. It will be too late in the painting stage, when things are not easily corrected.

How Much Detail Does a Drawing Need?

When attempting a painting with a number of intricate details, you'll need a good drawing to follow. Include as much detail in your drawing as you will need to ensure accuracy in your painting.

I love detail, so I find that over 90 percent of my work requires detailed drawings. By taking time to draw carefully, I will have a painting that more closely resembles what I want it to look like, with fewer errors.

Go Ahead and Project!

I have extensive drawing experience, including four years dedicated to figure drawing. Drawing is a process I enjoy. I've always felt that if you were to be a "real" artist, you had to draw. This feeling is shared by many artists, and yet many of those same artists trace behind closed doors because tracing has been considered a "dirty word" in the art community.

When I wrote to a friend and fellow artist about my concerns, his reply changed my thinking completely. He said, "I started using projected images when I had only weekends to paint and was looking for a quicker way to get to the act of painting. I was just learning how to paint. I knew I could draw." He then said, "You have to decide: Are you a drawer or a painter?" I had always thought of myself as both, but in all honesty, if I want to paint many paintings, I can't spend weeks drawing before ever picking up a brush.

I project a lot more now—tracing mainly the major shapes—then I fill in those shapes with freehand drawing. Remember, however, that when you project, you're standing to one side, so you will foreshorten or elongate one side or the other. Switching sides halfway through the drawing will only make the middle of your drawing look compressed. With some knowledge of perspective drawing, you can fix these distortions. Often the solution is to draw the middle area of the projection, find a few leading lines, then freehand the rest of the image yourself.

I still advocate learning how to draw, but the bottom line is you shouldn't feel like any less of an artist if you speed up the drawing process by tracing parts of projected images.

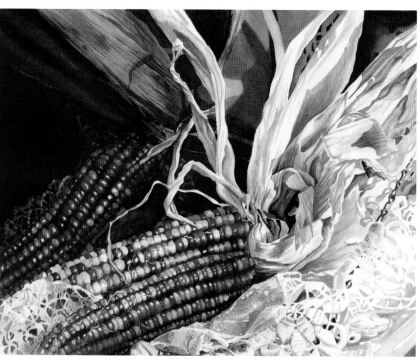

Nailing the Details in the Drawing Stage
The strength of this painting is actually in the wonderful negative shapes formed by the cornhusks. I wanted these shapes toward the center and the cobs to direct the eye toward the area of interest. The drawing had to accurately place the kernels on the cobs, as these tend to twist and turn, and I wanted to straighten some and ensure they were in a believable formation. I also needed a map for the lace in the foreground so it, too, would be realistic. I wanted to show the pattern in the lace, which my mother had crocheted, so it would represent her work well.

Indian Corn
Watercolor on cold-pressed paper
15" x 18" (38cm x 46cm)
Private collection

My Drawing Process
After I evaluate a photo and am certain that I want to paint from it, I:

1. **Move the photo to a computer and tweak it.** I usually compose the image to the proportions the painting will be. I heighten the contrast a bit so I can see the detail more clearly.

2. **Have a 35mm slide made from the digital file.** Find a photo processing house that can do this for you so you have an image to project.

3. **Project and draw.** Fasten your watercolor paper to a wall with drafting tape, then use a projector to project the image onto the paper. It usually takes me three or four hours to trace the image,

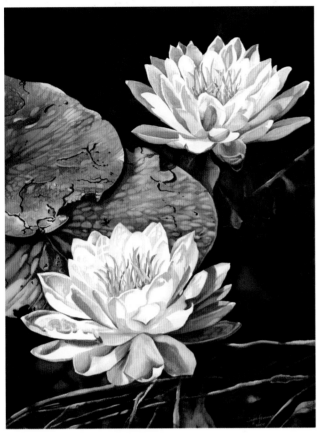

Less Detail, Less Drawing
Reflections required very little drawing because there are large expanses of water, so I could improvise in those areas and still make them believable. I needed only to place the lily and the pads with a soft outline before beginning my painting. I wanted to show the underwater plant life and reflections on the water, but I planned for those things in my mind rather than making a detailed drawing.

Reflections
Watercolor and colored pencil on cold-pressed paper
26" x 19" (66cm x 48cm)
Collection of the artist

then a couple more hours of freehand drawing to add detail from a printed photo. During the drawing process I may move objects around, change their sizes, and so on to improve the overall composition. I may even bring in details from another photo.

4. **Lift some of the graphite before painting.** When I have completed my drawing, I use a kneaded eraser to lift off some of the graphite. By rolling and kneading the eraser over the paper, you will lift the graphite but leave the paper unharmed so that the paint applications to come will not be altered. The lines are still visible, but less obvious, so if your paint traps any graphite, it shouldn't be as noticeable.

Progressively erase lines as you paint. Once the painting is finished, you may have to check for lines you missed. Light

areas are the greatest concern as lines there are easily seen and can be distracting. Generally the lines in darker areas are hardly visible. Fortunately, if you are erasing as you go, this shouldn't be a problem.

Drawing Tips

Work from enlargements. Going from a projected image to a tiny photo can wreak havoc with your eyes. Enlarge your photos to 8" × 10" (20cm × 25cm) or so to better see what is happening in them.

Hands off! The natural oils, sweat or lotion on your skin can alter the paper so it won't accept paint evenly. (See page 115 for what can result from your fingerprints.) Handle paper carefully, and place a paper towel under your hand and arm to prevent them from smudging the paper as you draw.

Draw in all the value changes you think you will need. This includes highlights, whites and darks. Make very sure your dark shapes are accurate and interesting. I think dark shapes need to be the most interesting, as the eye seems to be drawn to those areas, and those areas often are what lead the eye around the painting.

Use code. If there are small white areas I must save, I will often write a small "w" there to help me remember to save that area.

Decide if there are areas that would be better penciled in later. Your hand can smear the graphite as you are painting, so if there is a lot of detail drawing to be done, it is wise to draw these areas as you go rather than all at once. Then you can block in the local color, erase and move on to another area. I often work this way when doing complicated lace patterns.

Use a Grid to Help You Draw
A grid can help keep your drawing in proper proportion and perspective. Draw one directly on an enlarged copy of your reference photo, or place the copy under a gridded sheet of acetate. Lightly pencil a corresponding grid (scaled up as needed) on your watercolor paper, or simply grid the area that troubles you. As you make your drawing, compare the grid squares to keep on track.

On the next four pages are four very different paintings. Each may be unique, but all contain the elements of strong composition. The accompanying photos show what I started with. From there I evaluated what I saw and made a series of decisions to improve the image enough for a successful, light-filled painting.

As you plan and put together your own paintings, decide where you want to:

- rearrange or keep things as they are
- simplify or embellish
- play down or emphasize

These decisions will affect all the color, value, shape, line and texture choices you make. Decide where you want the viewer's eye to focus, and build your painting around that.

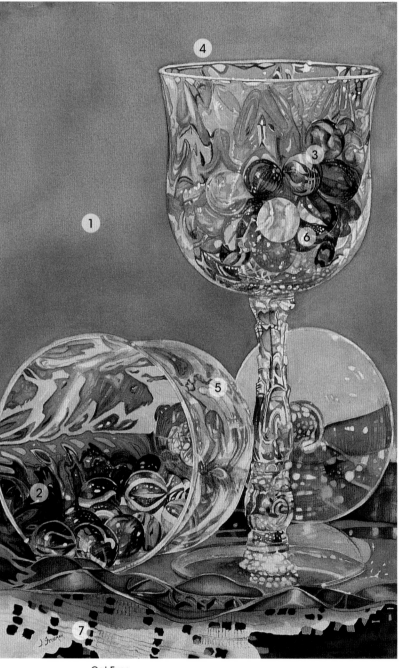

Cat Eyes
Watercolor on cold-pressed paper
21" x 14" (53cm x 36cm)

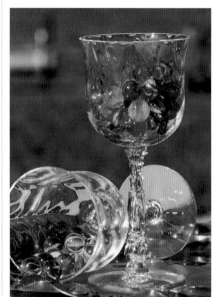

Making an Entrance
The glass resting on its side helps to direct the eye into the scene and offers a more interesting view. The copper tray provided a nice unexpected dark shape in the lower glass.

1 The background colors blend well with the marbles and unify other elements.

2 The copper tray behind the glass adds darks for depth.

3 Each marble has unique shapes within shapes, creating variety.

4 Circular elements of the glasses echo the marbles for rhythm, interest and unity.

5 Generally, lighter values give the painting the feeling of more light.

6 Its lightness and off-center placement makes this marble a perfect focal point.

7 The high-contrast lace is kept simple so it won't detract from the marbles.

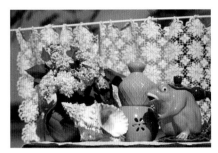

Critical Cropping

I was mainly drawn to the shell, vase, flowers and lace, so I eliminated the right half of the photo.

1 Lightening this area and exaggerating the lace reflected in the pitcher produces greater light.

2 Additional negative shapes in the lilacs bring them to life. Added darks push the lighter flowers forward.

3 The rough white shell plays against the smooth turquoise shadow for the focal point.

4 The light holes break up the shadows, adding interest to the pitcher.

5 A reflection keeps this area from being a boring blank space.

6 This flower curves toward the shell's point, forming a circle of interest that moves the eye upward.

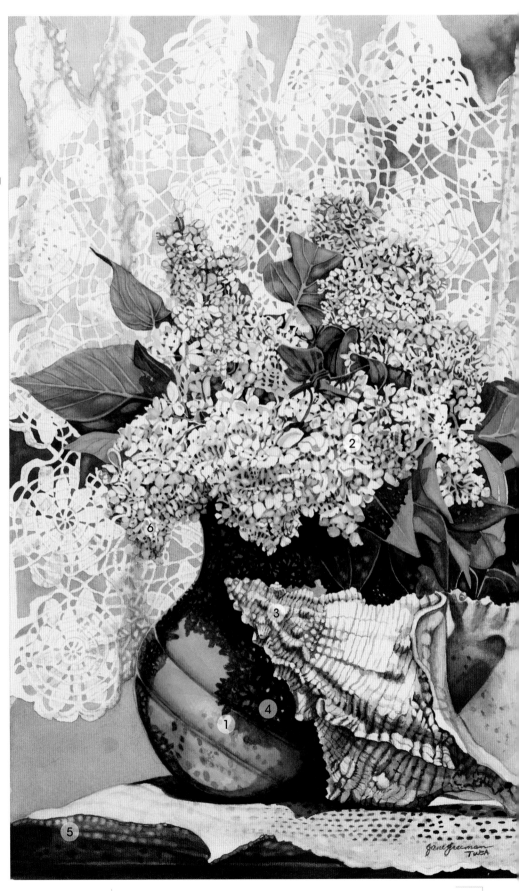

Summer Gifts
Watercolor on cold-pressed paper
21" x 13" (53cm x 33cm)

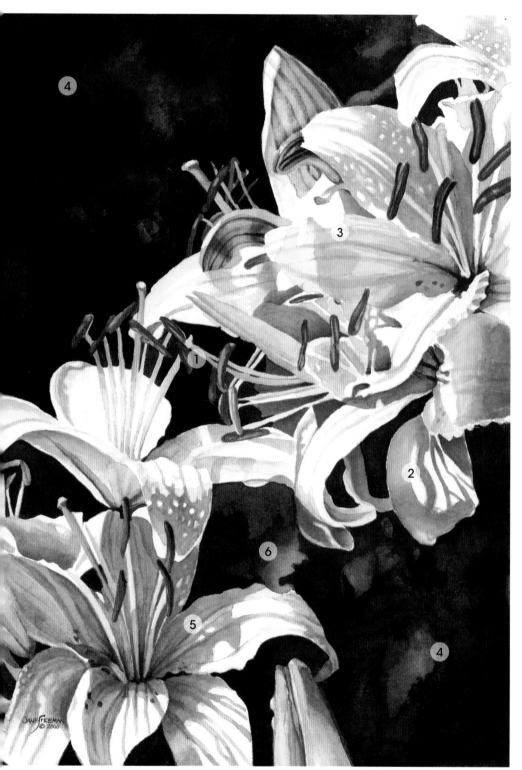

1 The negative dark shapes among the sta-
mens create the focal point.

2 The warm, rather abstract shadows on the
lower petals indicate strong light and heat.

3 Rather than delineate every petal, I
focused on the overall lily shapes.

4 The two dark corners anchor the painting
while pushing the whites forward.

5 The shadows glow when changed to a
brownish red and intensify the whites.

6 A hint of foliage adds texture and interest
to the background.

Asiatic Lily
Watercolor on cold-pressed paper
14" x 10" (36cm x 25cm)
Collection of Joe and Jane Welle

Zooming In

I zoomed in for a more intimate view. I felt
the subject needed a dark background to
push the lilies forward, which creates a nice
diagonal.

1 Blue shadows, red geraniums and the pale yellow-gold building fulfill a triadic color scheme.

2 Sheer Quinacridone Rose glazes signal sunshine on the shingles and warm up the pot shadows.

3 Lightening the shadow under the shelf looks truer to life than the photo.

4 Light holes in these shadows suggest eye-catching sunshine passing through the blooms.

5 The grass breaks up the white. Slightly darkening the board's edges as they reach paper's end keeps the eye in the painting.

6 The upright tail feathers point the eye toward the upper part of the painting.

7 The dark color is subtle enough in contrast to allow for a gradual discovery of the bird.

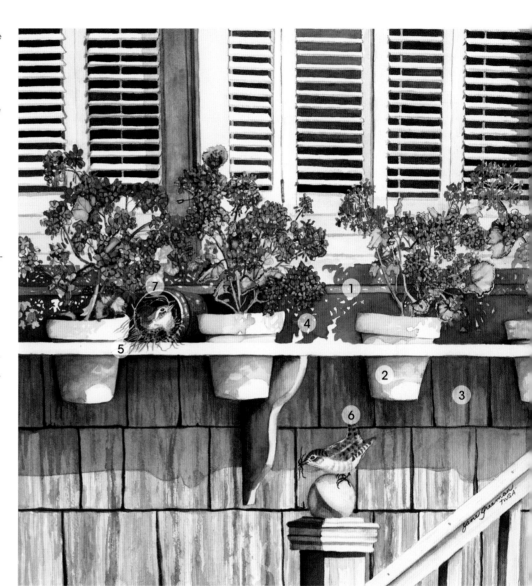

Adding a Little Life

The photo of the pots was strong, but I wanted to add some human interest. I settled on the small wren after taping a sketch of him on the post. After that, the one in the pot was a natural addition. The birds are meant to be eventually discovered rather than immediately spotted.

Anticipation
Watercolor on cold-pressed paper
15" x 14" (38cm x 36cm)

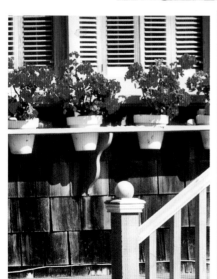

Peggi, placing the fruit in *Cherries, Berries* in bags is unique. How did that come about?

In my studio, I put the fruit in small trick-or-treat paper bags rescued from my considerable collection of possible props and arranged them in a small wooden crate. Having good props you can use over and over makes setting up a still life much easier! I call this one of my signature formats because I have used it before in paintings, and it is very successful for me. The style is one I refer to as "pattern painting" because there is no obvious focal point. I carefully planned for a rhythmic movement of color, value and form. Well-thought-out directional lines lead the eye across the composition.

How did you achieve this lighting?

I positioned a spotlight to simulate the effect of bright sunlight falling at an angle across the composition. This created exciting transparencies in the shadowed areas of the paper bags. It also made for dramatic highlights on the fruit, which helped to make things pop!

I know you draw and paint from life. How did you approach working with fruit?

I studied each fruit intently, holding them in my hand until I felt I understood thoroughly the texture and form. Thus, when I began painting, I was not fighting the ripening process of the fruit. My memory enabled me to record their freshness accurately.

How did you capture the highlights on the berries?

When I encountered the blackberries, they kept appearing as if they had chicken pox. As I reworked them, I would at times end up with the highlights being too dark. I used cotton swabs to lift some color but was not successful. I hesitated to use the tip of a razor blade, as I wanted to avoid tearing the paper. I found the coarsest sandpaper and cut two diamond-shaped pieces from it, then glued them back-to-back on a popsicle stick. With the pointed ends I carefully removed only the pigment so that the paper would not be scratched...I was able to achieve a gradation between the highlighted areas and the shadowed areas of the nodules of the blackberries. If I had indented the paper by lifting with a scrubber brush, it would have caused any further pigment to sink in and darken in value.

Peggi Batcheck, a self-taught watercolorist, has received over sixty awards in regional and national exhibitions since her first entry in 1998. Her work has appeared in such publications as International Artist's *How Did You Paint That? 100 Ways To Paint Still Life* and *The Artist's Magazine*. She resides in Columbus, Ohio. Visit her website at www.peggibatcheck.com.

A Painting Well Planned

Morning sun cast a brilliant light, resulting in dramatic cast shadows, reflections and highlights. A simple bowl, a richly faceted platter and a black silk backdrop offer eye-pleasing variety in shape and texture. The crystal's beveled edges and facets echo the cone-shaped fruit, and the starburst leaves mimic the platter's scalloped edges and the bowl's rim, creating an attractive rhythm.

Strawberries Fostoria
Peggi Batcheck
Watercolor
12" x 16" (30cm x 41cm)
Private collection

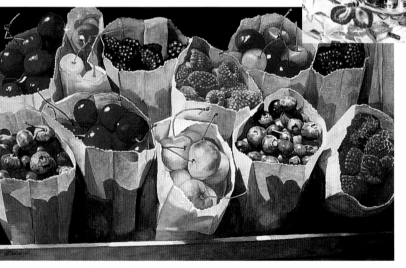

Cherries, Berries
Peggi Batcheck
Watercolor
16" x 26" (41cm x 66cm)
Private collection

Peggi's Composition Tips

- Make light one of the most important elements in planning a dramatic painting. It is the first element I consider when designing a still life.

- Plan for a variety of geometric shapes and textures that will create a rhythmic movement of light and color.

- Try an overhead viewpoint. A subject that in everyday life might be given a cursory glance will be seen from an optimum point of observation.

Laurin McCracken is an accomplished painter, architect and photographer. His award-winning paintings have appeared in *American Artist*, *Watercolor*, *The Artist's Magazine*, *International Artist* and several books on watercolor, including *Splash 9*. Laurin lives in Fort Worth, Texas. Visit his website at www.lauringallery.com.

Laurin, these two paintings look nearly identical at first glance, even sharing three of the same objects, but the colors in the reflections are quite different. What caused this?

The primary lighting in both photos was the same—a 75-watt daylight bulb in a 10" (25cm) aluminum reflector—but the still lifes were photographed at different times of day: *Glamis Castle Rose* in the late afternoon, revealing warmer colors, and *White Lightnin'* in early afternoon when the colors were bluer. The color shifts were caused by the secondary natural light that came in through the windows. Later in the day, sunlight is filtered through more and more of the atmosphere, since the angle of light increases. This causes a shift in the color of the light to a warmer shade. While the primary source is pretty strong, even the weak secondary light source is enough to affect the color temperature.

Were there any other differences in how the two scenes were set up?

There are a number of reasons why the colors are different in these two paintings. The silver was more highly polished in *White Lightnin'*. Also, the napkin in *White Lightnin'* made things whiter, while the lemons in *Glamis Castle Rose* made things warmer as the light bounced around from them. I was looking for a warmer look in *Glamis Castle Rose*.

How does the direction of the light factor into your paintings?

The lighting in my paintings is always from the left side. There is a centuries-old tradition of having the light source on the left. It is very rare to see the light source on the right. We are so used to seeing things with the light coming from the left that it is a bit more difficult for our brains to process images that are lit from the right.

It seems you've trained your eye to pick up on even the slightest nuances that, collectively, can greatly affect the entire painting.

It is always fascinating for me to see how the smallest bit of color in any object in a still life can change the character of the color of the whole composition. The light reflects and refracts over and around the silver and crystal in wonderful and mysterious ways. I am always finding a bit of color where I would least expect it. That is one of the joys of painting silver and crystal.

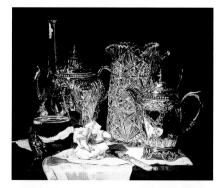

White Lightnin'
Laurin McCracken
Watercolor
20" x 28" (51cm x 71cm)
Collection of Thomas Kraig

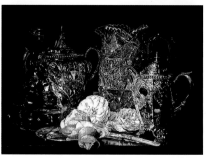

Glamis Castle Rose
Laurin McCracken
Watercolor
20" x 28" (51cm x 71cm)
Collection of Lawrence and Jan Farrington

Laurin's Composition Tips

• A single light source will give you stronger shadows and therefore more clearly define the shapes of the objects. Multiple sources tend to confuse the viewer, especially when conflicting highlights and shadows are created, unless one of those sources is considerably weaker than the other and is used for a focused purpose.

• Don't be a slave to the photograph. You can enhance the composition by moving things, even slightly. Adjust values or enhance shadows to make objects more intelligible.

• The more detailed your drawing, the more detailed your painting can be.

• Silver and crystal are not just a range of grays. Portray the many colors that get reflected and refracted around their surfaces.

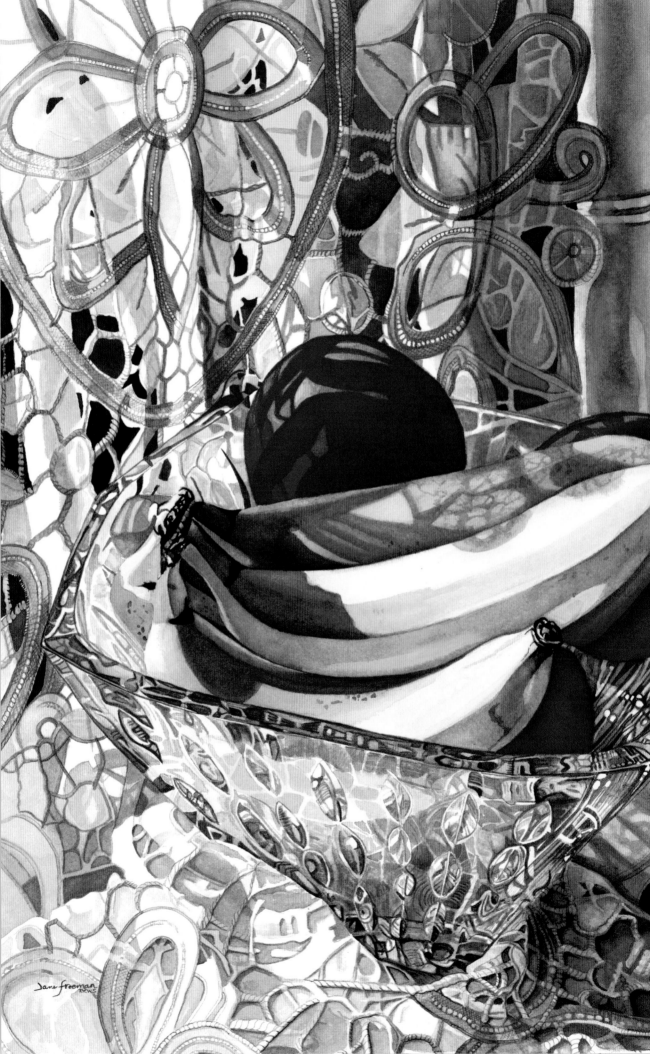

LIGHT AND COLOR

"Value does all the work and color gets all the glory."

—Unknown

The Color Created by Light
To give the viewer the sense of light in this painting, I taped a lace tablecloth to the window so that it would cast shadows across the fruit and give me some interesting patterns. The cast glow of color onto the lace in the lower-right side of the painting indicates that light is passing through the bowl onto the lace.

Bananas Fostoria
Watercolor on cold-pressed paper
18" x 14" (46cm x 36cm)
Collection of the artist

I was born and raised in western North Dakota, where the prairie meets the sky. My parents had a cattle and wheat farm, which is where I first became infatuated with light and color. Sunsets on the prairie in the summer can turn everything pink and gold, and shadows are truly purple! Because I worked in the fields past dark in August hauling grain, I was well aware of how long the shadows could get and how they could deepen in color and melt into darkness. I saw how the sun could shine so intensely that colorful tractors would fade into a whiteness of brilliant light.

This chapter introduces you to my colors and how I use them in my paintings. It will also show you how to mix and use grays to make contrasting colors sparkle. Most of all, I hope it will help you become courageous with color, knowing that color breathes life into the shadows of your paintings.

Taking advantage of the benefits of some basic color phenomena will allow you to better manipulate color in a painting to achieve the exact effect you're after.

Complementary colors attract attention, so place them wisely. The colors directly across from each other on the color wheel create excitement when placed beside each other in a painting. The eye is instantly drawn to that area, so use complements carefully.

Make a color seem brighter or more pure by placing its complement beside it. If you have a red cherry, for example, you'll find that surrounding it with green will enhance its redness.

Apply the color scheme that fits the mood you want to establish for your subject. An overall complementary color scheme generates excitement and suggests activity. An analogous color scheme is more calming and serene.

Use cool color to emphasize warm color, and vice versa. Consider the temperatures of your colors relative to the other hues in a painting as you make color decisions. Always think, Is this a cool or warm color? If it is warm, then placing a cool color behind it or beside it will make it appear even warmer. A daffodil will appear more intensely yellow on a background of green leaves; a cool blue sky behind it will make the flower appear even warmer.

Make areas of your painting recede or come forward by varying the temperature and value. Light values and warm colors come forward. Darks and cool colors recede.

Use temperature shifts to signal light and shadow areas. Use cooler variants of a hue to indicate shadows (particularly form shadows) on an object, or warmer variants to indicate areas receiving more light. Because cool colors recede, applying a cool blue wash to the edge of a warm yellow-green leaf will make that area appear to be in shadow. The sunlit side of a blue vase might need a red glaze to signal warmth, bringing that area forward.

Aim for similar values in areas that you want to de-emphasize. Those colors that are closest in value tend to blend together. Use similar values in areas of your painting that need to be quieter

Complementary Colors Make the Subject Pop
The red bracts of the poinsettia plant stand out because its leaves are the exact opposite hue (green) on the color wheel.

Snowman Wishes
Watercolor on cold-pressed paper
17" x 14" (43cm x 36cm)
Collection of JD and Marlene Martin

and less noticeable, so that other areas can emerge as focal points. Incorporating both low-contrast and high-contrast areas into your painting will allow the eye to naturally move to the center of interest where the highest contrast or activity is going on, and use the passive areas as transitions.

ALTERING AND EXAGGERATING COLOR

Each of us looks at the world and personally interprets what we see. I am very conscious of colors, so I paint the colors I see, but I find that exaggerating or altering them even a little adds my own touch. I might make up a color for something in a painting, but most often I see a hint of that color in my subject and play off it. Color is life to me, so I seek out color even in the darkest darks or gray areas. Conversely, sometimes it's necessary to play down a color if it interferes with the mood I'm trying to convey.

Ask these questions as you consider color:

What are the local colors of the subject? Are these the best colors to work from for the painting, or should they be brightened or toned down to support the mood of the painting?

Do all the colors help tell the story? Where the scene takes place, what the time of day is, whether the temperature is cool or warm, if the scene is peaceful or lively?

Does the light appear particularly sunny or warm on certain areas of the subject? Can you find the warmth and magnify it?

Is there a color in the shadows you can strengthen so it is not just a drab, dark area?

Do all your colors work together? Remember, a photo does not always tell you everything, and its colors may mislead you. Follow your instincts. It is your song, so sing it like you feel it.

1 Veins were added and darkened, exaggerating the folds in the petals.

2 A circular pattern invented for the front flower adds texture and interest.

3 Lightening the buds keeps them from attracting too much attention.

4 Cooling the greens brings out the warm color of the irises.

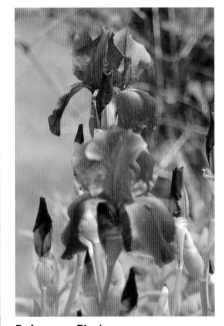

Reference Photo
The reference photo doesn't show much detail, so I exaggerated what I could see and made up other things to make it more interesting for a painting. This piece was juried into the Transparent Watercolor Society of America, giving me my signature.

Isla's Iris
Watercolor on cold-pressed paper
28" x 21" (71cm x 53cm)
Collection of the artist

USING COLORS IN LIGHT AND SHADOW

Never be afraid to use color. Your job as the artist is to entertain the eye as it moves through your work, so plan for wonderful color surprises in the shadows or other unexpected areas and you will begin to see your paintings become more full of life, light and depth.

Some tips:

Think correct value, not correct color. Whether you are painting flowers or silver or fabric, the item you are portray-ing will be a specific color in your photo or setup, but it surely does not need to be that exact color in your painting. What's more important is to have correct values. The eye reads realism mainly by the proper placement of lights and darks, not by true-to-life color.

Spot opportunities to break up solid color with varied color. A brown tabletop will be more interesting if it is not just a solid, mousy brown. Introduce some reds or violets into shad-

Reference photo

Drama in the Darks

The light in *Pear Tea* seems more intense because the shadows are so dark. The purest colors appear near the focal point, and sur-rounding grayed colors make the area more prominent.

Pear Tea
Watercolor on cold-pressed paper
14" x 18" (36cm x 46cm)
Collection of Marlene Fechette

ows and maybe make the sunlit areas more golden; the table will still read as brown but will have much more interest. I prefer to make this variation very subtle, but that is easy with my process of layering color.

A color does not need to jump off the page to glow. Subtle colors that glow are often the prettiest and most natural.

How to Paint Shadows

The true hue of a color is apparent in light, but place the color in shadow and it changes. So, how do you go about painting shadows?

Tailor Shadow Colors to Each Painting

I do not like to have predetermined color recipes for shadows, as I think one needs to see what each situation calls for and be open-minded and flexible with colors. Often I will add colors to the shadows to give them a little extra zing. Using colors that exist in other areas of the painting will connect the shadows with the rest of the image so they don't appear isolated.

1. **Discover what is in the shadows that your photo might not be telling you.** Deep shadows can create dark holes in a photo. Paint them that way and they will appear as dark holes in your painting. Have your reference photo lightened if necessary to better see the details in the shadows. You need to have that information to make the shadowed areas appear realistic.

2. **Paint the details first.** The fact is, until the shadow arrived, you could see all those details. A shadow moves across and lies on top of an object, so to paint the shadow first doesn't really make sense.

3. **Once everything is painted, lay the shadow color gently over it, just as it would happen in nature.** This allows several things to occur. First, no matter how dark you take that shadow, you will retain some of the information you painted. Even if the area becomes very dark, a texture or suggestion will remain to add interest. Second, with the shadow color over the top, the detail will soften. Most things seen in shadow look diffused and have softer edges. That softening will help the area appear more realistic.

Reference photo

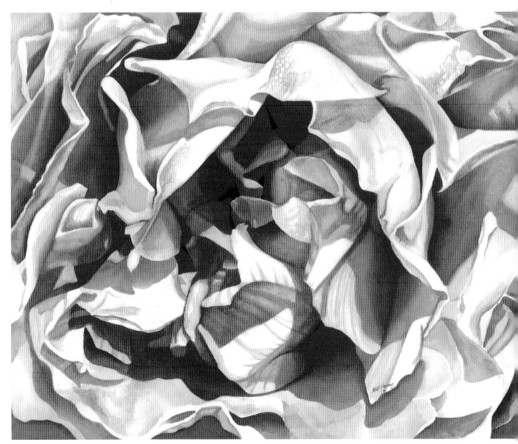

Soft Lighting Reveals Subtleties
High contrast was not something I felt I needed to find the shapes of the petals that describe this bloom. Grayed hues make the more intense colors pop and the whites seem even brighter.

Heart of a Rose
Watercolor on cold-pressed paper
14" x 19" (36cm x 48cm)
Private collection

Paul, you have done a number of paintings with instruments in them. How does this one differ?

Jazz in Blues is an instrument still life, reminiscent of a series of watercolors I did in the 90s. However, those earlier still-life paintings were lit by the white light of the sun, while *Jazz in Blues* is lit by a more complicated, colorful glow of neon signs.

Choosing neon lights surely would provide you with a lot of extra color, and I suspect that is where you found those wonderful darks as well.

I wanted to give the impression of the light in a jazz club, creating an atmosphere that would bring the instruments to life.

How did you achieve those darks?

This painting required a lot of pigment to create the rich darks that surround the colorful reflections in the instruments. I built the color through a series of layers, allowing only the highlights to peek through. The shadow areas

are massive, but not uninteresting. A lot of detail captivates and moves the eye through even the darkest areas.

Your choice of colors is interesting. Was there a specific color palette you were using?

You may notice a Quiller watercolor palette underneath the still life. This provided some great rhythm and motion, plus an opportunity to experiment with how other colors appear in the blue light. Some of my colors were French Ultramarine Blue, Cadmium Red, Cadmium Orange, Cadmium Yellow, Permanent Alizarin Crimson, Winsor Violet and Winsor Blue (Green Shade).

What are your thoughts on using grayed colors?

Who needs muted colors? They seem to appear in the well of my palette on their own eventually!

Paul Jackson is the author of *Painting Spectacular Light Effects in Watercolor.* At 32, he was featured as one of the Master Painters of the world in *International Artist* magazine. In 2006, Paul's painting *New York Nightlights* received the prestigious Dong Kingman Award from the American Watercolor Society. He lives in Columbia, Missouri. Visit his website at www.pauljackson.com.

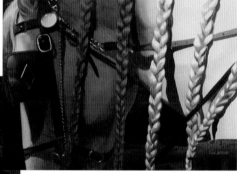

Storm
Paul Jackson
Watercolor on cold-pressed paper
22" x 30" (56cm x 76cm)

Changing White for Drama

For a more dramatic take on this white horse, Paul painted it very yellow. This gives the impression of a dark stall with limited light. He cropped the scene to show the most fascinating aspects, the bridle and braids. Adding yellow's complement, violet, to the scene creates vibrancy.

Jazz in Blues
Paul Jackson
Watercolor
26" x 40" (66cm x 102cm)

Paul's Light and Color Tips

- To create the highest sense of drama, use complementary colors.

- To draw the eye to the focal points, use the darkest and lightest values of these colors right next to one another.

- For the richest of color, build in several layers rather than mixing a really thick concentration of paint. Otherwise you will get a shiny buildup of gum arabic.

It's important to become familiar with the properties of the pigments on your palette. Understanding these traits will help you choose, mix and apply color wisely in your paintings.

Transparency

This quality involves how much light can be seen through a layer of paint. Transparent paints allow the white of the paper or the color of previously applied layers of paint to show through, while opaques completely block the light. Pigments range from transparent to opaque, with semitransparents and semiopaques in between.

Since a watercolorist's main device is glazing—applying layers of color on top of one another to create a desired color or value—you want mainly transparent and semitransparent paints on your palette. Some artists use opaques for areas where glazing isn't required to achieve a certain look; however, I removed them from my palette once I realized they could lead to muddy color. Opaques do give you deep, rich color, but you can achieve that by glazing multiple coats of more transparent color.

To test a color's transparency, paint a layer of it over a line of permanent black marker. If you can see the line through the layer, the color is transparent rather than opaque.

Staining Ability

Staining involves how easy (or difficult) it is to lift paint off the paper. To test the staining properties of a pigment, paint a swatch of that color and let it completely dry. Then use a soft, slightly damp scrubber brush to wipe a line across the swatch. Blot the area dry with a tissue and repeat. If the paint is easily removed in one or two passes, leaving a white line, the color is nonstaining. If slight color remains, it is low staining, but even then you might lift back to nearly white with a few more passes of your brush. The medium- to heavy-staining colors will never lift back to white, always leaving a lighter version of the original color. If you tend to make mistakes or like to lift color for highlights or other effects, you will want to use more of the nonstaining colors.

Lightfastness

This rating, given by the American Society for Testing Materials (ASTM), tells you the likelihood of a paint to fade over time. Steer clear of any color rated as "fugitive" or "low lightfastness."

Granulation

Granulation is the ability of the pigment to separate, creating a mottled effect—a characteristic desirable for making interesting textures. If you combine granulating colors, such as Manganese Blue Hue with Burnt Sienna, they will push away from each other for a speckled effect that is useful for portraying stucco, cement, dirt or rock. Stay away from granulating paints where you want smooth passages of color.

My Color Choices and Yours

My palette is always changing a little as I discover new colors. Do not be afraid to change your palette, because a new color can help your work stay fresh and current. The charts on the next few pages show the tube colors and mixtures I find most interesting to use. All are Daniel Smith paints unless otherwise noted. (See page 13 for more about my brand preferences and the colors I used to complete the demonstrations for this book.) Remember, you may not need all of these colors. You can mix many colors yourself once you get familiar with your paints.

I use only transparent or semitransparent paints, so if you have opaque paints, you might want to move them off your palette or cover them temporarily so you do not mistakenly use them while you are trying my painting method.

Whatever paints you decide to use, have the manufacturer's color charts handy so you know all the characteristics of the paint. For older paints, contact the manufacturer to find out how that version of the paint was rated, as many have updated and changed their paints to make them more durable and lightfast. Test the paints yourself to become familiar with what they look like and whether they lift, separate or stain.

Buyer Beware

The same name does not always mean the same color when it comes to watercolor paints. The properties of each color may vary from manufacturer to manufacturer. Test brands before you buy, as colors of different brands may share the same name, but can look or act somewhat (or totally) different. Check www.handprint.com. The site runs its own lightfastness tests and constantly updates information on all paint brands, so it is an excellent site to find out how your paints stack up against those of other brands.

Yellows

Generally, I use my yellows as a basecoat if I want an area to glow. For instance, painting yellow in the sunlit area of flowers and then glazing the flower color over it will give the feeling of sunshine coming through the petals.

One undesirable quality of yellow is its ability to trap graphite, making your drawing very hard to erase. When you use yellow, erase most of your lines first or they will be visible in the finished piece.

Greens

I prefer to mix most of my greens. Mixed greens are more believable and can unify your painting if you mix them from the blues and yellows already in use. If I am not already using a blue, or if I cannot make the green I need with the colors I am using, I will incorporate a tube green. Any tube green can be mixed with other pigments to make a more pleasing green.

Sap Green is a frequent performer on my palette. I use it with blues to make nice blue-greens for shadows. I mix it with the yellows or blues that I am using in a painting to create my leaf colors. Also, it mixes for lovely browns.

Favorite Mixed Yellows

Adding these yellows to the gold creates a cleaner yellow for glazing.

Quinacridone Gold + Aureolin

Permanent Yellow Deep + Quinacridone Gold

Glazing with this gives a very clean wash of sunlight wherever you apply it.

New Gamboge + Aureolin

The gold knocks back the color a little, which works well for shading.

Glaze of Quinacridone Gold over New Gamboge + Aureolin

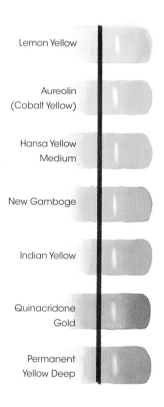

Lemon Yellow

Aureolin (Cobalt Yellow)

Hansa Yellow Medium

New Gamboge

Indian Yellow

Quinacridone Gold

Permanent Yellow Deep

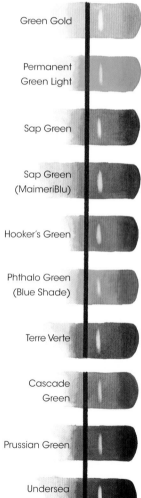

Green Gold

Permanent Green Light

Sap Green

Sap Green (MaimeriBlu)

Hooker's Green

Phthalo Green (Blue Shade)

Terre Verte

Cascade Green

Prussian Green

Undersea Green

Favorite Mixed Greens

Phthalo Blue
(Green Shade)
+ New Gamboge

Manganese
Blue Hue + New
Gamboge

Adding New
Gamboge to vari-
ous blues creates
unique greens.

Cobalt Blue
+ New Gamboge

Indanthrone Blue
+ New Gamboge

Sap Green +
Phthalo Turquoise

Sap Green +
Indanthrone Blue

Separates a little
and makes a soft,
springlike green.

Sap Green +
Manganese
Blue Hue

Sap Green +
Indigo

Blues

It may seem like I have a lot of blues on my palette, but since I paint a lot of florals, I like being able to mix a variety of believable greens. I also need several good light blues for skies and some darker blues to create shadows or to darken other colors.

So far I've not found any blue I would rather have than Indanthrone Blue. It helps to darken browns and is wonderful with Sap Green for painting shadows on leaves.

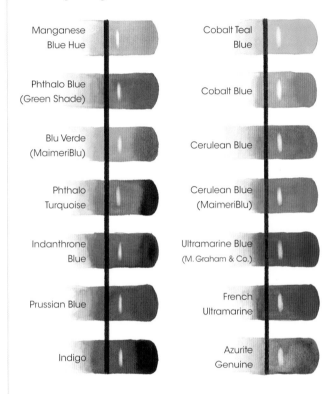

Manganese Blue Hue	Cobalt Teal Blue
Phthalo Blue (Green Shade)	Cobalt Blue
Blu Verde (MaimeriBlu)	Cerulean Blue
Phthalo Turquoise	Cerulean Blue (MaimeriBlu)
Indanthrone Blue	Ultramarine Blue (M. Graham & Co.)
Prussian Blue	French Ultramarine
Indigo	Azurite Genuine

Favorite Mixed Blues

Adding a dark
color to a staining
color like Phthalo
Turquoise gives
you a nice dark.

Phthalo Turquoise +
Indanthrone Blue

Phthalo Turquoise +
Indigo

These make
good sky colors
because their
transparency
lends an atmo-
spheric feel.

Manganese Blue Hue
+ Phthalo Turquoise

Manganese Blue Hue
+ Cobalt Teal Blue

Reds

I am often asked how to make realistic reds. I don't really have a formula, but I rarely use just a tube red. I try to glaze using several reds to make the color richer. Layering several hues gives more depth than a single dark layer of color. Also, by glazing pinks, yellows and reds, you can achieve a very luminous red.

I love all the Quinacridones shown here, but if I could have only one, it would be Quinacridone Rose because it has proven indispensable to me. I glaze it over yellows to make oranges and over reds to make them glow, and I mix it with blues to make the best violets.

Quinacridone Coral

Quinacridone Pink

Quinacridone Rose

Quinacridone Red

Quinacridone Fuchsia

Quinacridone Magenta

Pyrrol Orange

Perylene Red

Naphthol Red (M. Graham & Co.)

Perylene Scarlet

Anthraquinoid Red

Pyrrol Crimson

Favorite Mixed Reds

Pyrrol Orange + Quinacridone Rose

Pyrrol Crimson + Quinacridone Rose

Perylene Red + Quinacridone Rose

Perylene Scarlet + Perylene Red

Naphthol Red + Quinacridone Rose

Anthraquinoid Red + Quinacridone Rose

Perylene Scarlet + Quinacridone Rose

Pyrrol Crimson + Quinacridone Burnt Scarlet

Anthraquinoid Red + Quinacridone Rose

Pyrrol Crimson + Naphthamide Maroon

Shown is one wash of each mixture. Add another layer of the same color or a glaze of Quinacridone Red or Rose and they would be even richer.

Violets

I mix many of my own violets. When I need a violet, I often mix it from the reds, pinks and blues I'm using on that particular painting to keep things unified. Shown are only a few mixed violets; your options are limited only by the number of reds and blues you have. Test your own paints.

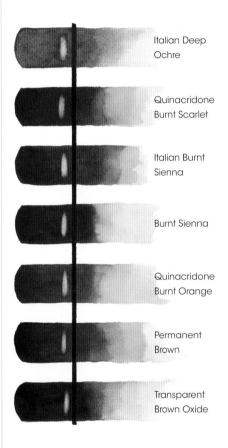

Cobalt Violet Deep

Quinacridone Violet

Carbazole Violet

Naphthamide Maroon

Permanent Violet

Raw Umber Violet

Moonglow

Browns

Experiment with mixing some of your own browns, because they can be prettier than tube browns. Mix Sap Green with each of your reds and see what you get. Try another green with your reds as well to make even more browns.

Italian Deep Ochre

Quinacridone Burnt Scarlet

Italian Burnt Sienna

Burnt Sienna

Quinacridone Burnt Orange

Permanent Brown

Transparent Brown Oxide

Favorite Mixed Violets

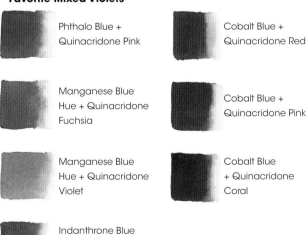

Phthalo Blue + Quinacridone Pink

Cobalt Blue + Quinacridone Red

Manganese Blue Hue + Quinacridone Fuchsia

Cobalt Blue + Quinacridone Pink

Manganese Blue Hue + Quinacridone Violet

Cobalt Blue + Quinacridone Coral

Indanthrone Blue + Quinacridone Violet

Quinacridone Violet is very staining, so use with caution.

Favorite Mixed Browns

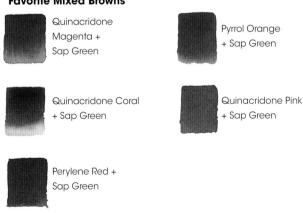

Quinacridone Magenta + Sap Green

Pyrrol Orange + Sap Green

Quinacridone Coral + Sap Green

Quinacridone Pink + Sap Green

Perylene Red + Sap Green

THE LIMITLESS POTENTIAL OF
THE LIMITED PALETTE

Every few months a new color arrives on the market. I'll admit I'm as big a sucker as anyone for a new color, and I usually break down and try a few new ones every year. Occasionally a new color will make it onto my main palette. However, no matter how many colors are available to me, rarely do I use more than six to ten tube colors for a painting. Why such a limited palette? Because:

A limited palette makes a painting look more harmonious and unified. Using too many colors can have a garish, disjointed effect. The eye cannot flow easily from color to color because colors will pop out everywhere. Picking the main colors you think you need and then creating the rest of the colors from that palette helps to maintain unity within the painting.

Limiting your colors will make you color-smart. You will be forced to make the pigments work for you, and you will get to know their characteristics a lot faster. You will be surprised how many beautiful colors you can mix from only a few paints.

The mixing knowledge you gain will help you compare and pick the best colors for a given situation. Let's say your blue has been Cobalt Blue and now you add Indanthrone Blue. You will be able to try it, compare and decide which blue you prefer for specific things. Cobalt Blue mixed with New Gamboge creates a cool grayed green; mix Indanthrone Blue with New Gamboge and you'll get a dark, rich green. If your painting is warm, the cool Cobalt Blue mix will not do, but if it is a cool painting, that mix might be just the ticket.

Reference photo

Make Your Colors Less Limited by Making Adjustments

Placing the little green tomato near red and yellow sets up a complementary spot that attracts the eye. The tomatoes on the box recede because their colors are made duller. I added some red to my Transparent Brown Oxide so the box blended in more with everything else. The green writing is dulled so it becomes secondary to the box's brighter greens.

Happy Boy Farm
Watercolor on cold-pressed paper
19" x 13" (48cm x 33cm)
Private collection

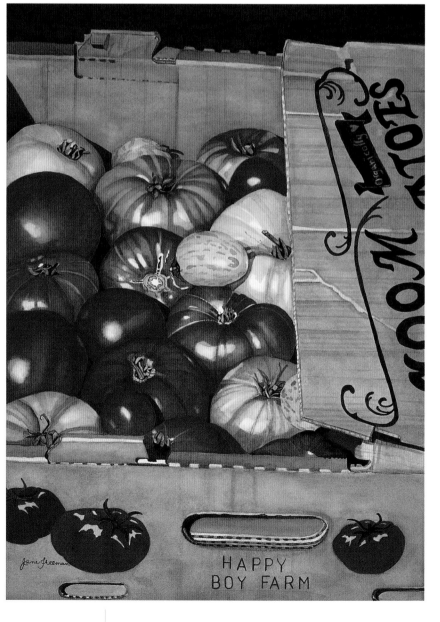

How to Select Your Palette

When choosing colors for a painting, follow these guidelines:

1. **Find the major objects in your painting and decide what tube colors will be required to achieve a likeness.** Your subject matter will dictate the colors you use. If I need a red, several reds might be required to achieve that shade. I might need several blues for something else. Experiment to make sure you have what you need.

2. **Decide what colors you'll need to mix with the colors already chosen to complete the rest of the painting.** Do you need a good violet? If so, will the reds and blues you've chosen mix well enough to give you what you want? Or, do you need to rethink one of those colors? Can you mix some pleasing greens with the blues and yellows you've already chosen, or do you need to add a tube green? It may help to make a color chart comparing the colors and the mixes you can make from them. Then you can determine what tube colors you need to add.

3. **If your painting has some very dark values in it, make sure the colors you've picked can make the dark color needed.** Some colors just cannot become dark, so learn which can and which can't. Indanthrone Blue is one of my favorites, as it can become very dark when layered or mixed with other colors.

4. **Don't overlimit yourself.** If I can succeed with four colors, I will paint with four; but if I find I need a Quinacridone color to glaze some life into an area, or another color for some reason, I do not hesitate to add it. Just make sure it agrees with the tone of the overall painting. If I need twenty tube colors, I will use twenty. A limited palette is not a rule, but rather a useful tool to help unify your work.

Make Connections With Recurring Color

Using complementary purple (Carbazole Violet and Quinacridone Rose) for the lace shadows near the yellow roses helped the flowers pop. Repeating the same purple from the lace shadows for the cup and saucer's shadows creates unity. Giving the tassel area washes of Quinacridone Rose and yellow made it reflect the colors in the roses. The green of the cup is repeated in the shadow of the upper part of the tassel.

High Tea
Watercolor on cold-pressed paper
19" x 15" (48cm x 38cm)

It's no secret that some darks are necessary for every painting. Darks provide the lovely contrasts that give depth and drama to a painting. Learning to make them is very important to your painting success.

For darks with depth, mix them from colors. I never use tube blacks, although other artists do, with success. I mix my darks because I like to see a hint of color in them, for interest.

You can mix darks, even black, by combining three primaries or two complements. Some combinations work better than others, so you must play around with the pigments and their ratios to see what your colors will do. A popular formula to achieve black is a deep red plus a deep green.

To mix a dark color you must use dark, saturated colors. Indanthrone Blue is one of those dark colors that can help you achieve a good mixed black or dark. Indigo is another nice dark you can add to a mixture for a different look.

The colors you use in a painting should dictate how you mix the darks. Try to mix your darks from the colors already in the painting to create a more unified look. Darks mixed from other colors can look out of place.

Experiment with your paints and make your own color charts. Constantly test different color combinations to learn what colors work well together.

Darks can be made by layering color over color. Many glazes may be required, however, to achieve the correct value. Also, you must watch the colors you're glazing to get the correct shade.

Color Helps the Viewer Read Your Subject
Dark red draws the eye to where we then focus on the single cherry that is painted realistically. The eye interprets all of the other darks as cherries even though they are represented by abstract shapes. Exaggerating the near-complementary blues in the crystal helps move the fruit forward and gives the bowl a more open and translucent feel.

Bowl of Bings
Watercolor on cold-pressed paper
14" x 18" (36cm x 46cm)

Indanthrone Blue + Perylene Red

Indanthrone Blue + less Perylene Red

Indanthrone Blue + Sap Green

Indanthrone Blue + Sap Green + Perylene Red

Colorful Darks
Try using Quinacridone Rose in place of Perylene Red. Then try Indigo instead of Indanthrone Blue. Adjust the ratios of color to see how that affects the mixtures. Experiment!

We have been taught that gray is drab and boring. Someone who is ill is said to look gray or ashen. And who wants gray hair? Well, in art, it is quite the opposite. Grays can make your painting beautiful and are well worth your time to learn how to mix and use.

You can mix a gray by combining three primaries or two complementary colors. This is also how you mix darks, but it is the ratio of the colors used that determines the outcome. Not all mixed grays are beautiful. I do find, however, that making gray is more successful with transparent and semitransparent colors than with opaque.

Mix grays from colors already in your painting. This will help unify your work.

Grays can be made by layering separate colors on top of each other. Artist Arleta Pech discusses her technique of glazing grays on page 53.

If you want a color to pop, surround it with a grayed color. Have you noticed when you are outside on a gray day that the colors in the garden seem more intense? Gray seems to showcase color. Placing gray next to any pure color tends to make that color seem even brighter.

Use grays in areas that you want to recede. Grays not only make surrounding colors look brighter, but also closer to the eye. Gray colors are great for backgrounds or other areas that need to attract less attention so that your center of interest stands out.

Colorful grays add interest and depth to areas such as shadows. There are many different colors and shades of gray to choose from.

Grays Make the Star Stand Out
Between 5 and 6 in the morning, I like to see how some colors, like the red of these tomatoes, stand out in the dark. Painting the rest of the image prior to the tomatoes helped me decide which reds to use to maintain the tranquil mood. Pushing the grays toward purple (Indanthrone Blue plus Perylene Red) added more life while keeping the scene soft. A red glaze over the cup and wall unified those areas with the tomatoes.

Morning Meditation
Watercolor on cold-pressed paper
16" x 12" (41cm x 30cm)

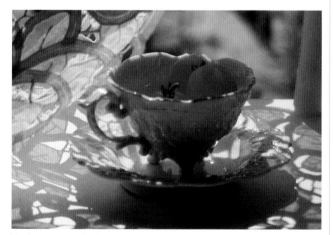

Reference photo

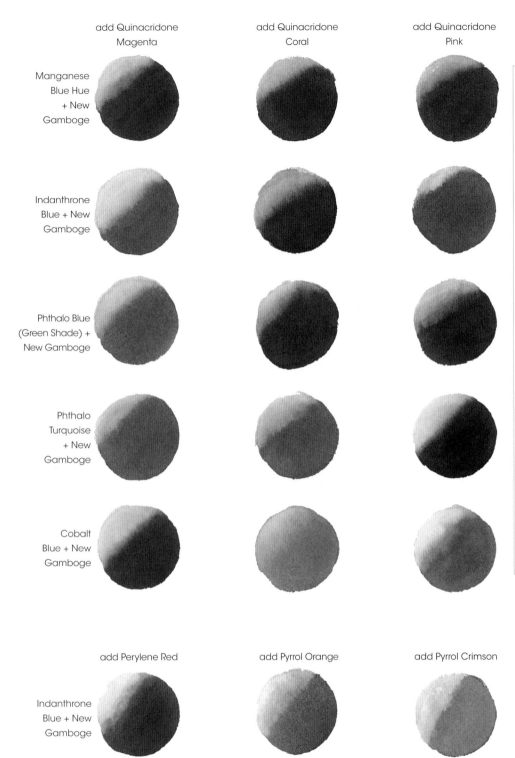

add Quinacridone Magenta

add Quinacridone Coral

add Quinacridone Pink

Manganese Blue Hue + New Gamboge

Indanthrone Blue + New Gamboge

Phthalo Blue (Green Shade) + New Gamboge

Phthalo Turquoise + New Gamboge

Cobalt Blue + New Gamboge

add Perylene Red

add Pyrrol Orange

add Pyrrol Crimson

Indanthrone Blue + New Gamboge

Preview Your Options

Sometimes it is impossible to imagine how a color is going to look in a painting. Resolving a gray area in a painting is even harder. How many shades of gray are there, and do you want it cool or warm, or dark or light? By going to a paint store and picking up paint chips you can preview or "try on" various colors and see if you like them. This should help you narrow your options. Hold the paint chip up to the area where you are thinking of using a similar color, squint, and see if that color works with the colors beside it. Often the paint chip comes in graded colors so you can also see what it might look like in a darker or lighter value. This can save you from making a nasty error and give you the confidence to apply paint on those areas in question because you've already had a sneak peek at the results.

Endless Possibilities

This chart shows just a few of the possibilities for mixing gray colors. I love these muted hues and think they are the backbone of any good painting. For each row I chose a blue to use with my constant, New Gamboge, and added that to three different reds. Not only do the colors make a difference in the resulting gray, but I could create even more varieties by adding more or less of any of the three pigments. Make color charts like this one to have handy when you are not sure what you need to create a certain color.

Arleta Pech is the author of *Painting Fresh Florals in Watercolor.* Her work has also been published in *Australian Artist*, *The Artist's Magazine*, *American Artist* and *International Artist.* She resides in Arvada, Colorado. Visit her website at www.arletapech.com.

Arleta, please tell us how you used gray in *Hydrangea Melody*, and how you made those gray areas glow.

Grays are important to my images as they unite the strong color areas with a soft gray transition area, such as the white container in this painting. I work with a very limited palette, so I use the primary colors of the painting to create the gray areas. This retains the color harmony though the entire painting. But to keep the grays glowing, I glaze one color at a time to achieve this look. Mixing the colors together to make a gray does not allow the variety individual glazes do.

What colors did you use to paint the grays?

On the container I used Permanent Rose, Ultramarine Blue (Green Shade), Burnt Sienna and Antwerp Blue. I painted each color in a single glaze and then let it dry before I applied one of the other colors. I repeated this process, adjusting the placement of each glaze so that in certain areas the colors overlapped to change the hue of the gray. White containers reflect colors from the surrounding objects, so a final, thin green glaze added a color bounce from the leaf.

Getting the right consistency to accomplish a correct glaze is so important. How thin are your glazes?

The glazes were the consistency of tinted water, so it took many glazes of each individual color to achieve the values and variety in the gray that is seen here.

Arleta's Glazing Tips

- Work with clean, primary colors.

- Let each glaze dry completely before applying the next glaze.

- Leave some of the previous glaze showing to build values.

- Individual glazes of color shimmer more than premixed colors.

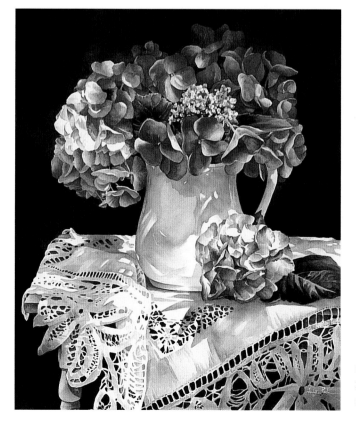

Hydrangea Melody
Arleta Pech
Watercolor on cold-pressed paper
22" x 19" (56cm x 48cm)

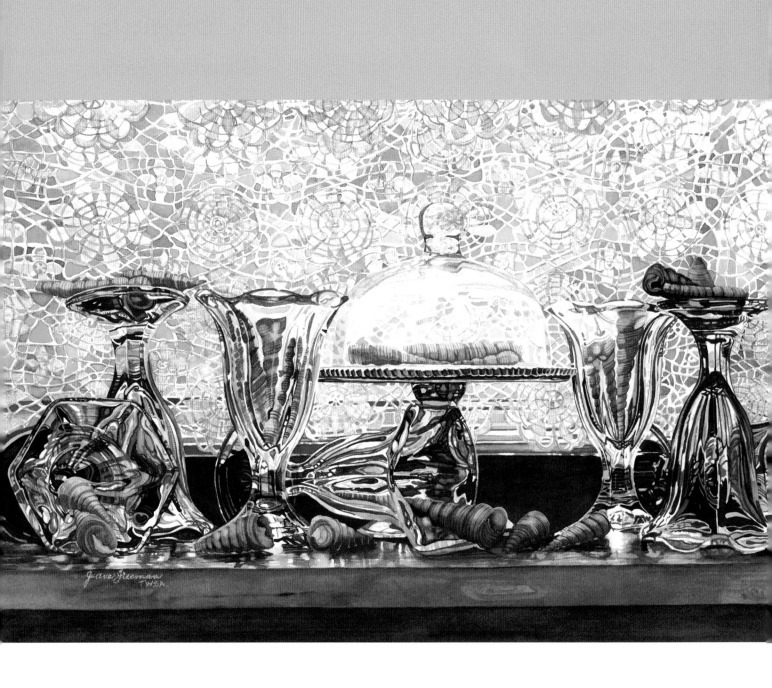

"Your style is the way you talk in paint."

—Robert Henri

TECHNIQUES FOR PAINTING

Light-Creating Techniques
The key to the success of this painting was capturing the glow of light coming through under the shells on the window ledge. I accomplished this by saving the whites and glazing with luminous washes to create a stark contrast with the darks that are there. Priming and glazing were used on the shells and windowsill to make them stand out against the drab background.

Sundaes on Padre
Watercolor on cold-pressed paper
13" x 20" (33cm x 51cm)
Collection of the artist

There are as many painting techniques out there as artists who use them. Even though many techniques are similar, each artist imposes his or her own style or unique twist, making it their own. You will find certain methods just feel natural to you, and those will be the ones that you incorporate into your work.

My main watercolor methods are *priming, glazing, direct painting* and *lifting*. I avoid techniques that involve a high degree of risk or chance because I like consistency and do not particularly relish "happy accidents." Regardless of the techniques you choose to use, remember that technique is only one step in the whole painting process, albeit an important one. Good technique cannot save a poor composition from becoming a mediocre painting.

My method of painting is similar to other watercolorists in that I wet the area to be worked on with clear water, then I place the paint there. Artist Susan Harrison-Tustain calls this *priming*, a term she graciously allowed me to borrow for my book. I love the term because it accurately explains what is being done. Priming prepares the paper to accept the paint, allowing a smoother application of color. It also gives you more control over where the paint goes. Prime only within the specific area you want to paint, and the paint will stay within that area as long as you aren't careless with your brush.

I use this technique not only for preparing the paper for the first layer of paint, but for subsequent paint layers as well. When I am doing sheer glazing, priming allows the paint to set on the paper without disturbing the previously applied and dried layers of color.

Priming Tips

Bring the water up to the lines you have drawn. I recommend beginning with a very good drawing to give you a precise map of the shape so you can be accurate with your priming and color application. Lay a wash of clear water over the area you've drawn, being careful to have smooth, even edges.

Remember that your paint will flow into any area where there is water. When you have an even sheen with no puddles, apply a wash of color and watch it spread into the area you have demarcated with the water.

Use a smaller brush to push the water, then the paint, into the tight places. Make sure it goes into any crooks and crevices you have drawn, and that the edges are smooth.

If you are priming a large area, you may have to re-prime it several times. Parts of the paper may be thirstier than others and soak up the water rather quickly. You want an even sheen of water over the entire surface you are going to paint. If you have to prime three times, then do it, as this will be essential for the success of your wash. For a background, I often do several glazes to either add other colors or to darken the color. Each time I wet the entire area so there will be no lines left. Water alone can leave a line, so you must cover the whole area to avoid a visible line where you left off.

1 Prime With Water
Apply water evenly to the shape with your brush. Be sure to stay within the margins.

2 Immediately Apply the Paint
The applied water will help the paint spread, and you can guide it into all areas of your shape with your brush. Carry the paint to the margins for a clean, definitive edge.

Dried finish

On primed paper, paint dries slowly, so you can take your time for a controlled application.

On unprimed paper, paint dries fast, so you must work quickly. Uneven color and sloppy edges can result.

Mopping

What if you want a gradation of color rather than an even application of paint? Cover the entire shape with water, but apply the paint only where you want the concentration of color to appear. Then, using a damp brush and a long, continuous stroke, pull or "mop" the paint into the rest of the area so it fades out gradually. You will need to rinse your brush and tap it on a tissue several times as you repeat the process until the edges blend softly into the next color.

This technique is used to isolate a wash or glaze and is often used for shading or for color variations within an object. Remember, you must wet the entire area again so there will be no lines before applying the color.

If you prime with too much water, the applied paint pools to the edges, leaving a hard line.

If you prime with the right amount of water, the paint dries evenly, without a hard edge.

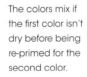

The colors mix if the first color isn't dry before being re-primed for the second color.

The underlying color shines through the top color if dry before re-priming.

Correcting Overpainted Edges

Using a soft scrubber brush and clean water, come into that area from a clean side or the lightest side so you do not disturb the paint inside the shape. Blot quickly with a tissue and repeat until the color is lifted as much as possible. Nonstaining, transparent paints lift easily, but staining or opaque paint is nearly impossible to lift (though you will be able to lighten it to some degree).

Glazing is simply the stacking of individual colors or layers of the same color, allowing the paint to dry between layers (or glazes). You might use it to:

- gradually build up darker values of a single color
- create a new, unique color by glazing one hue over another
- make a slight but critical change to a colored area by adding a glaze
- warm or cool, play up or tone down areas of a painting

Why not just premix the color you want, or apply the dark value you desire from the get-go? Because your glazing patience will be richly rewarded. You simply cannot achieve the same luminous color with premixing that you can with glazing. With glazing, the previous layer of color shows through the colors applied on top of it and remains a part of its true color. And, when you glaze to build darker values, the result is depth-filled, dimensional color instead of the harsh, flat, lifeless look you'd get if you just applied dark color from the start.

I do not paint entire paintings using glazing because it is very time-consuming. I use it where I want previously applied colors to show through the later layers. Where I need a glow to occur, instead of painting around a yellow underlayer, I glaze other colors over the yellow and then lift back to that hue. The result is depth that creates a much more realistic look.

Glazing Tips

Let your paper dry completely between glazes, laid flat. Use the back of your hand to check it. If the paper feels even slightly cool, it is not dry.

Always begin with light washes of color and glaze lightly. This allows you to build up color gradually and to alter the color as you go. If you use too heavy a glaze you will cover up the colors below it, defeating the purpose of this technique. Remember, you can always go darker, but if you scrub an area to make it lighter again, it will never glow like the pure white of undisturbed paper.

Stick with transparent and semitransparent colors. This allows you to glaze back and forth between colors without too much risk of getting mud.

Try out layering combinations on scrap watercolor paper. Play with your paints all the time to see which glazing combinations work well and which don't. Test combinations you're considering before applying them in a painting to be sure you like them.

Keep track of layering combinations you like. Write down the colors used underneath a sample swatch and store these swatches in a three-ring binder for easy reference.

Quinacridone Rose mixed with Indigo

Indigo glazed over damp Quinacridone Rose

Indigo glazed over dry Quinacridone Rose

Premixing your colors may give you a lovely gray as shown here, but for livelier results, glaze colors instead.

Don't rush, adding glazes before the previous layer is completely dry. The result will be solid mixed color, not glazed color.

Do allow one layer of color to dry completely before adding another. Luminous, gorgeous color will occur.

The effects of glazing one color over another can range from slight adjustments to the original hue to the creation of an entirely new color.

Quinacridone Rose over itself

Quinacridone Rose over Perylene Red

Quinacridone Rose over Perylene Scarlet

Quinacridone Rose over Transparent Brown Oxide

Quinacridone Rose over Carbazole Violet

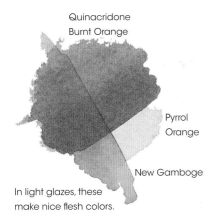

Quinacridone Burnt Orange

Pyrrol Orange

New Gamboge

In light glazes, these make nice flesh colors.

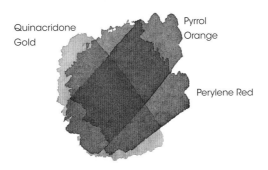

Quinacridone Gold

Pyrrol Orange

Perylene Red

The gold darkens and would work as a warm shadow for a flower of this color.

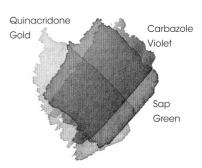

Quinacridone Gold

Carbazole Violet

Sap Green

The gold warms up the cool layers. Try this for under leaves where light is bouncing around.

Quinacridone Gold

Quinacridone Rose

Quinacridone Sienna

This mixed burnt sienna glows and is completely transparent.

Quinacridone Rose

Quinacridone Burnt Orange

Carbazole Violet

This rich color could not come straight from a tube.

Pyrrol Orange

Quinacridone Magenta

Permanent Brown

Though darker, the final value is brightened by Pyrrol Orange.

Quinacridone Rose

Carbazole Violet

Quinacridone Rose

This combo deepens pink realistically. Ending with the first color applied softens the transition.

Pyrrol Orange

Quinacridone Burnt Orange

Quinacridone Rose

This red-orange is very natural and believable.

Quinacridone Gold

Pyrrol Orange

Quinacridone Rose

The gold tones down a rather loud orange.

Pyrrol Orange

New Gamboge

Quinacridone Rose

The yellow radiates through the other colors only if you glaze lightly.

Green Gold

Carbazole Violet

Phthalo Turquoise

Phthalo Turquoise over Green Gold makes a nice shadow for sunlit leaves. The violet glaze makes a gray that glows.

Quinacridone Rose

Pyrrol Scarlet

Indanthrone Blue

The scarlet glaze makes the color glow.

59

Susan, what was your inspiration for *Oceans Apart*?

This is a self-portrait. Not exactly a portrait of myself, but a story about how awed and uplifted I am when I look out across the vast ocean and know that somewhere, at the end of that sea and in a faraway land, my daughter lives her dreams and my dreams for her. I described the feeling of calm and peacefulness by inviting the viewer to first of all look at the portrait, then follow her gaze past the foreground wave and across the serene waters to the horizon.

You always have such beautiful, true color in your work. Can you tell us your secret?

I love to see my paintings glow with fresh, clean color. The secret to this is my use of transparent pigments. Applied in fine veils of color, these luminous hues can become jewel-like. Each transparent layer allows those layers that have gone before it to glow through and influence the final color. Imagine placing pieces of stained glass one on top of the other. This is the effect I am after: glowing, vibrant, luminous color.

You said you've discovered how to make those colors really sing. How?

Before I begin any painting, I lay in a very pale underwash of yellow. Now, imagine you are creating a tonal painting—black, gray and white only—and create those same values using yellow. Very light, almost white areas have an almost imperceptibly fine underwash of yellow. Deep, dark final colors can have up to five fine underwashes of yellow that allow it to glow. Yellow underwashes radiate through the subsequent color washes. They also do another miraculous thing: they add real substance to the subject. They take away that raw look of watercolor and give the painting a feeling of tangibility.

So you don't necessarily save whites?

I always tone my paper. What appears to be white never really is white. Once that toning is dry, I determine where I wish my "whites" to remain pale, and I ensure that these remain clean and fresh by painting around those places. With each layer, I soften the edges of those lightest areas to ensure a soft gradation rather than a hard edge.

Explain your priming process and what it accomplishes.

The purpose of this method is one of building up fine washes, allowing the pigment to be absorbed into the inner layers of the paper. Very little pigment is left sitting on the surface of the paper. Therefore, only a minimal amount is disturbed by subsequent washes. My priming method reduces the risk of creating "mud" in watercolor, producing soft gradations of transparent color instead.

Using my priming and yellow underwash methods, you will create magical yet natural colors—just as Mother Nature intended. I use these methods to paint every subject.

Susan Harrison-Tustain, a self-taught artist whose work focuses on naturalistic realism, is the author of the best-selling book *Glorious Garden Flowers in Watercolor*. Her award-winning paintings have been featured internationally in books, numerous magazines and her own art instruction videos. She resides in New Zealand. Visit her website at www.susanart.com.

Oceans Apart
Susan Harrison-Tustain
Watercolor on hot-pressed paper
27" x 19" (69cm x 48cm)
Private collection

Susan's Steps for Priming

1. **Wet the entire area to be painted.** Allow the paper to absorb the water just until the sheen has left the surface.

2. **Moisten the paper again.** The amount of water used at this stage depends on the effect you are after. The less water you use, the more control you have. The more water you use, the gentler the blending.

3. **Float in your pigment wash.** Once each set of primed washes is complete, allow your work to become bone-dry before adding the next set.

DIRECT PAINTING

When painting directly onto your paper:

1. **Mix enough of the color you're painting with** beforehand so you can do the job without stopping.

2. **Thin your paint mixture with enough water** that the mixture flows evenly from your brush.

3. **Fill your brush by slowly twisting it in the paint rather than dabbing or poking.** The bristles should come to a nice point from which the paint can flow in a controlled manner.

4. **Keep your brushed coats light.** You can always apply additional coats as needed to make an area darker or richer in color, but you cannot so easily remove it.

5. **Work quickly so no painted area dries before you are done with it.** If an area begins to dry as you are working, your brushwork will leave unwanted lines and your washes will look uneven.

no. 10 round	no. 8 round	no. 24 round

Look at how many different stroke widths each individual round can achieve, no matter its size. A round brush that comes to a good point is a very versatile tool.

Don't Waterlog Your Brush

When I paint I always have a tissue in my hand for dabbing my brush to remove excess water. I'll also pinch the brush between two fingers to express extra water onto the tissue. I do this so automatically that I am unaware of it. Some artists keep a towel beside their clean water for blotting.

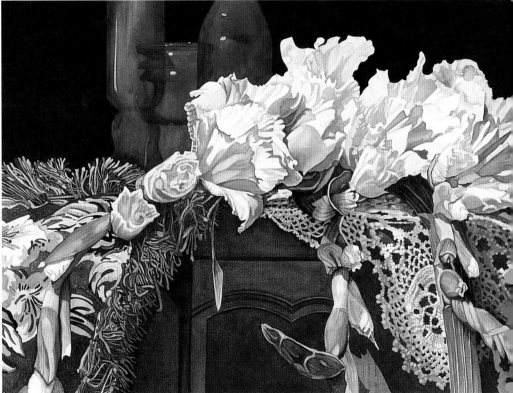

Direct Painting for Uncomplicated Color
Instead of glazing multiple colors to create the blue vases behind the flowers, I painted them directly because they did not need to glow.

Repose
Watercolor on cold-pressed paper
20" x 28" (51cm x 71cm)

Sometimes you need to lift color that you've already applied. You might do this to:

- strengthen or find an edge
- regain a lost white or create a highlight
- create negative shapes
- correct a mistake

If you find that you're lifting frequently to correct mistakes, remember that working lightly and slowly building up color can save you from more work next time.

Dry blending is a technique some artists use when they are adding a small area of color and need to blend it into an adjacent color that is already dry. Dry blending helps to smooth a transition between two colors or values. This technique is most often used when fine-tuning areas toward the end of the painting process, particularly in places that need a small color adjustment or a little deeper shadowing.

Lifting Tools

Scrubber brushes, sponges and even toothbrushes can be used to lift color. Most of the time I use a scrubber brush for lifting color. They come in many sizes and seem to work best if color needs to be lightened once dried or lifted entirely for a highlight.

You can also use a thirsty (slightly damp) brush to lift color or to herd color into a contained area. After each pass over the color, rinse and blot off your brush so you are not transferring color back into the area you just lifted.

If you use transparent or semitransparent colors, lifting will be so much easier. To gain more control of the shape you create when lifting, apply low-tack masking tape around the area to be lifted.

Sponge Lift
Use low-tack masking tape to mark the line you want to lighten against, making sure to press the tape edges down firmly. Moisten a small sponge and squeeze the excess water out. Run the sponge several times over the area next to the tape, dab with a tissue to blot up the dampened paint, then remove the tape. You might not get down to white, but this will soften the color and help to delineate a line or straighten edges that you may have lost or messed up, such as on a table or a cup.

Scrubber Lift
If the pigment is staining, a sponge will not lift as much paint as a scrubber brush will. Follow the same process as for the sponge lift, but use a scrubber instead to remove the color. Work quickly and pat with tissue to keep water from seeping under the tape. Lift the tape and you will have a crisp line.

Paper Fix
If you've done a lot of scrubbing, the paper surface will be disturbed and you'll need to flatten the fibers. When your paint is thoroughly dry, use the back of a white plastic spoon to gently press down the stray fibers, using a small circular motion. This area will not accept paint in the same way, but that could work to your advantage in a background because the paint you apply will look softer and more out of focus.

Instead of painting around veins, you can use a flat scrubber to lift them.

I lifted with a round scrubber to re-create the raised lace for *Repose* (on page 61).

Dry Blending

Use this technique when you have small areas of shading to do, for blending shadows and shading such small details as the veins in flowers and leaves. Soften the edge with a thirsty brush, then slide or wiggle the brush between the paint and the dry area. Be sure to rinse and blot your brush on a tissue first so you do not get too much water into that area and cause the color to spread or bloom.

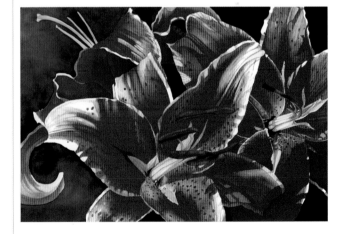

Resorting to the Toothbrush

What if a large area of your painting has gone sour? Bigger lifting jobs call for bigger equipment. Keep your old toothbrushes for this purpose. The worn, softened ones work especially well for this purpose. You can also use a toothbrush for stubborn areas that just won't lift with other tools. Work in a gentle, circular motion with clean water, then blot with tissue, repeating as necessary to remove all or most of the color. Then lay the paper flat to dry completely.

Create Edges That Suit Your Purpose

Most of the hard edges here are used to pop edges of petals forward so that the flower appears to be in front of another, or to define the edge of a petal against the background. The interior of the flower is soft and the petals need to convey that, so here it is important to make transitions by blending, glazing or softening edges with water.

Stargazer
Watercolor on cold-pressed paper
14" x 21" (36cm x 53cm)
Collection of Deb McGregor-Pfleger

James, texture is such an integral part of your paintings. How do you feel texture functions in your work?

In a painting, texture elicits a sense of recognition from the viewer and gives greater insight into the nature of your subject. The proper use of texture can set the mood of your paintings and will give them a greater sense of believability. How we use texture in a watercolor depends on many factors.

Which factor might be at the top of this list?

Among the most important is light. *St. George's* depicts a midday scene in this historical Bermudan town after a rain shower. The light is brilliant, abundant and more than sufficient to describe a variety of surface textures. You can clearly see the textural contrast between the rough stone buildings and the sparkle of raindrops on the glass and metal of the car.

How about in contrast to *Quiet Night*, which has such a different feel because it is evening? Do you mute the texture, or how do you handle that?

The texture in *Quiet Night* is altogether different. The light is diminished and much more delicate. The scene is backlit from the full moon, with the addition of a single light within the house. We therefore see some surface texture here and there—on the ground, for example—but little if any on the other surfaces. For the most part, much of the painting's texture—indeed, much of its interest—comes from the spiky silhouettes of the bare trees.

James Toogood is the author of *Incredible Light & Texture in Watercolor*. His award-winning work has been exhibited in more than thirty-five solo exhibitions throughout the U.S. and abroad. He has been featured in such publications as *The Artist's Magazine* and *American Artist*. James conducts watercolor workshops nationally and internationally.

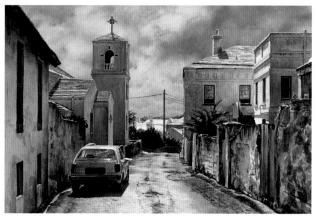

St. George's
James Toogood
Watercolor on cold-pressed paper
14" x 21" (36cm x 53cm)

James's Texture Tips

Scumbling and *drybrushing* are techniques you can use to add texture to your watercolor paintings.

- **Scumbling** is rubbing or scrubbing a thin layer of, typically, a more opaque paint over a previously painted surface. I scumbled for the rough stone walls in *St. George's* and some of the ground texture in *Quiet Night*.

- **Drybrushing** is similar but uses even less water. It is best done on paper that has a bit of texture. I drybrushed throughout much of *St. George's*, especially on the walls and the road.

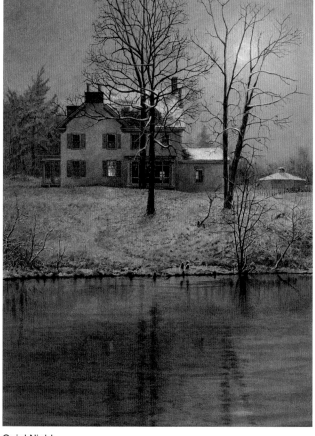

Quiet Night
James Toogood
Watercolor on cold-pressed paper
14" x 11" (36cm x 28cm)

STAMPING AND STENCILING

Applying paint using stamps or stencils works well in backgrounds for repeating patterns. After letting the stamped or stenciled area dry, I apply several washes of color over it. This pushes the pattern further into the background so it doesn't steal too much attention. Because they soften the edges, washes also make the design appear less like a stencil or stamp and more like you brushed it on.

Clear contact shelf paper can be used to protect parts of the painting when applying stencils or stamps to nearby areas. Here's how:

1. **Cut a piece to the size you need** to more than fill the area you are working on. Remove the backing and affix it to your painting so it covers what you need to protect by several inches.

2. **Carefully cut along the edge** of your protected area using a sharp craft knife. Use a light touch so you do not score the watercolor paper.

3. **Press gently** along all edges to make sure that it is sealed, and then proceed to stamp.

4. **Lift off the contact paper** when finished. The sticky side will adhere to the paper but lifts off very easily and leaves no residue.

For *Morning Meditation* (on page 51), I knew I wanted tile or wallpaper in the background. I knew exactly the pattern I was looking for, and after some searching I found a sponge stamp with a pattern similar to what I wanted. On this page is how I went about applying the pattern.

1 Protect and Plan Where You'll Stamp

After applying the contact shelf paper, cut along the cup edge and up the window edge, following your lines exactly. Remove the piece over the area that you will be stamping, leaving the rest in place to protect the cup and the rest of the painting. Use a ruler to divide the area to be stamped with the dimensions of the stamp, so you know where to place the stamp each time. Make sure lines are level and spaced evenly so your pattern will read correctly.

2 Stamp and Let Dry

Brush color onto your stamp and test it on scrap paper first. Then stamp on your color in the pattern you have marked off on your watercolor paper. Place scrap paper under the right edge of the painting so you can stamp onto it if your pattern will go past the right margin. Having your paint a little thicker ensures that it will not run under the contact paper. When complete, pull off the contact paper and let the paint dry.

3 Soften the Stamped Pattern

Lay washes gently over the area. The slight blurring of the stamp will soften the edges and push the stamped shapes into the background. In the full painting I applied several coats to deepen the wall value, pushing the stamping even further into the shadows.

Salt application is not a technique I use often, but it works wonderfully for textures such as cement, stucco, rock and rust. When you sprinkle salt onto wet paint, the salt absorbs the paint. Once the paint dries, brush the salt off to reveal unique textures and patterns.

Salt Tips

Experiment with different types of salt. For all the examples on this page, I used Morton coarse kosher salt. Table salt will give you smaller spots.

Apply somewhat stronger color than you think you'll need. The salt absorbs the color as it dries, so the result may be lighter than you were expecting.

Using more salt usually creates more texture. A light spot will be made by each salt crystal, so you must decide how much salt you will need to produce the effect you want. This comes with practice.

For different effects, play with the time between painting and sprinkling on the salt. For these examples I sprinkled the salt on immediately after applying the paint, but if you wait a little longer you will get a different effect. Be aware, however, that the outcome is never certain and always unique.

Wait until the paint is completely dry before removing the salt. Brush off the salt with a stiff cardboard edge or the edge of a credit card. If salt residue remains, trying gently patting the area with a clean, damp brush, then use a tissue to lift the remaining granules.

Try granulating paint or mineral paints for additional textural effects. Generally I prefer mineral paints when I want the most realistic texture. Granulating colors work well with salt for a mottled, highly textured effect, because not only does the salt push pigment away, but the colors push away from each other.

Conversations
Watercolor on cold-pressed paper
14" x 18" (36cm x 46cm)
Collection of Gary and Margo Breitag

The cement was made with salt on Indian Red + Cerulean Blue + Yellow Ochre.

more salt

less salt

salt on Lunar Earth + Hematite + Purpurite Genuine

more granulating

salt on Sap Green wash

glazed with Phthalo Turquoise

less granulating

More and more, I enjoy enhancing my watercolors with colored pencil. Some artists do the same with inks, acrylics or other mediums. Colored pencil can quickly add texture that might be difficult or take a long time to achieve using only watercolor. It can also create small details, such as a cat's whisker or an eye highlight, that might get lost during the watercolor stage. If you enjoy drawing, colored pencil may be a natural addition for you.

When I do add colored pencil, I use wax-based Prismacolor pencils over the dried painting. I've also added acrylics to my paintings on occasion. Have fun experimenting yourself, but do remember that you won't be able to enter your mixed-media paintings into most watercolor competitions, since the use of any medium other than watercolor would disqualify them.

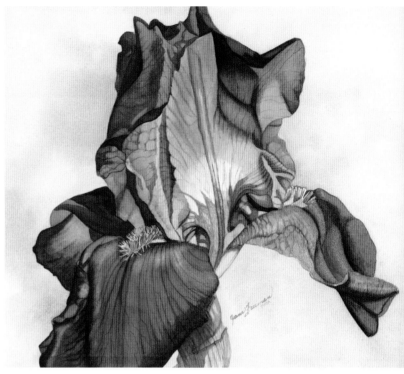

Using Colored Pencil to Achieve Elusive Texture
While painting this flower I was very unsure how I would achieve the velvety "stripes" on the falls of the iris that extend from the throat toward the petals. After several attempts, I tried colored pencils and loved the results.

Head in the Clouds
Watercolor and colored pencil on cold-pressed paper
15" x 19" (38cm x 48cm)

Flip Back...

Turn to page 29 and look again at *Reflections*. Shortly after completing *Head in the Clouds*, I decided to see how far I could take colored pencil on top of watercolor. Since I love to draw, I knew that the drawing process would be a lot faster than stacking sheer washes and glazes. I completed the full-sheet painting of water lilies in a week; normally I would spend three to four weeks on a painting this size. I felt this painting was very successful, but one thing I would do differently is paint the flowers entirely with watercolor, as I think I lost the glow I can achieve by stacking watercolors. These closeups show some of what I accomplished using the pencil.

I gave the lily pads a wash of Sap Green and New Gamboge, then simply drew in all the details.

The reflection in the water under the top lily is all colored pencil, which looks very realistic.

Sueellen, how do you begin a painting as complicated as *Before the Party*?

I had a great photo of a little poodle and its cast shadow, and I had a photo of a rug. All I needed was to decide where I wanted the dog in the composition, draw it in, and protect it from the rug and shadow colors by applying masking fluid to it.

I love the rug! How did you paint it?

After all the rug's colors were on, I applied a wash of pale shadow color (a diluted mixture of Burnt Sienna and French Ultramarine) over the whole thing, which softened all the colors and made the rug look old. Next, I mixed a large batch of dark shadow color using a heavier concentration of Burnt Sienna and French Ultramarine and applied it on top of the rug. When it was dry, I carefully softened the harsh edges of the shadow with a damp brush, taking care not to lift the colors of the rug.

You called upon several mediums when completing the dog. Explain your process.

First, I removed the masking from the dog. For the dark half of the dog, I painted from dark to light, developing a *grisaille* (tonal painting) with my dark shadow mixture, and filling in lighter and lighter areas of the fur. As I went lighter, I went warmer, adding a bit of Burnt Sienna to my mixture. I protected the lightest highlights on the head and forelegs by covering them with white colored pencil, and washed over the light areas with a pale mixture of warm-gray acrylic. Then I selected the next-lightest areas, covered them with pencil, and did a second wash of warm-gray acrylic. I did this four times (four light values). Then I erased the entire dog, making sure that all graphite pencil from the original drawing was removed. Finally, I softened the edges, warmed the fur and sharpened the features using colored pencil.

Sueellen Ross lives in Seattle, Washington, and is best known for her cat and wildlife portraits. She is a frequent contributor to the prestigious "Bird in Art" show at the Leigh Yawkey Woodson Art Museum and the "Arts for the Parks" show sponsored by the National Park Foundation. She wrote *Paint Radiant Realism in Watercolor, Ink & Colored Pencil*.

Before the Party
Sueellen Ross
Mixed media
16" x 12" (41cm x 30cm)

Sueellen's Mixed-Media Tips

- Spend time on your original graphite drawing. The more precise and detailed it is, the easier the rest of the process will be.

- Use India ink as your darkest value. Your work will have contrast, depth and drama.

- Do as much as you can with watercolor. It is faster and more luminous than colored pencil.

- Use colored pencil to do all the things you can't get done with watercolor: soften, detail and fix areas that look flat.

Janie Gildow is an internationally known colored-pencil artist. She is the author of *Colored Pencil Explorations* and co-author of *Colored Pencil Solution Book*. Janie conducts workshops throughout the U.S. and teaches regularly at the Arizona-Sonora Desert Museum Art Institute in Tucson. Janie resides in Arizona. Visit her website at www. janiegildow.com.

Janie, what made you decide to showcase these peppers with a white background?

Ever since I moved to Arizona, I've been fascinated with the quality of the light here in the Southwest, so I love putting objects on white paper to see what colors I'll see in their cast shadows. Lately I've been concentrating on the beauty of simple objects, and that led me to try some peppers. When I put those green and yellow peppers on the white surface in direct sunlight, I was totally blown away. The blue reflected in the shadows (from our endless and cloudless blue sky) added to the color, which was more gorgeous than I can possibly describe with words. I couldn't wait to share it!

I see you use illustration board for your work, so it must work well for your technique?

I love working on Strathmore illustration board when I combine watercolor with colored pencil. I usually apply the watercolor first and the pencil over it. The board takes the watercolor very well, and the tooth is magic. It allows the watercolor to peek through the colored pencil, creating wonderful and vibrant color combinations.

How did watercolor and colored pencil work together for *Peppers*?

I use watercolor as a means to an end, not as the end itself. Consequently, in *Peppers* there is colored pencil over every bit of watercolor. My colored pencil skills far outweigh my skill with watercolor. So for me, the watercolor tints the paper and creates a glowing color base for the pencil, speeding up the whole process, because colored pencil alone is slow-going. In my opinion, the combination of watercolor and colored pencil produces a richness and depth of color not possible with either medium alone.

Incidentally, only in the cast shadows did I actually grade the watercolor wash from one color into another. In the peppers I created some changes in value with watercolor, but the majority of color and value changes were done over the watercolor with the colored pencil.

Janie's Mixed-Media Tips

When you combine colored pencil and watercolor, you have a choice of which one you put down first.

- If you apply the wax pencil first, it acts as a "net" that accepts and captures the watercolor, as long as you use light-to-medium pressure and don't completely cover and fill the paper tooth with wax. For this method, first build color and value with the pencil, then use the watercolor as a wash to tint whatever paper is not covered by the pencil.

- If you want to let the watercolor do more for you, you can apply it as you would for any watercolor painting. Then, when the paint is dry, apply the colored pencil over it.

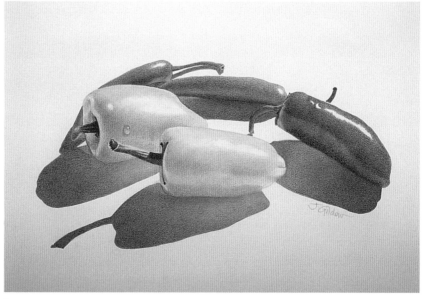

Peppers
Janie Gildow
Colored pencil and watercolor on Strathmore illustration board
5" x 7" (13cm x 18cm)

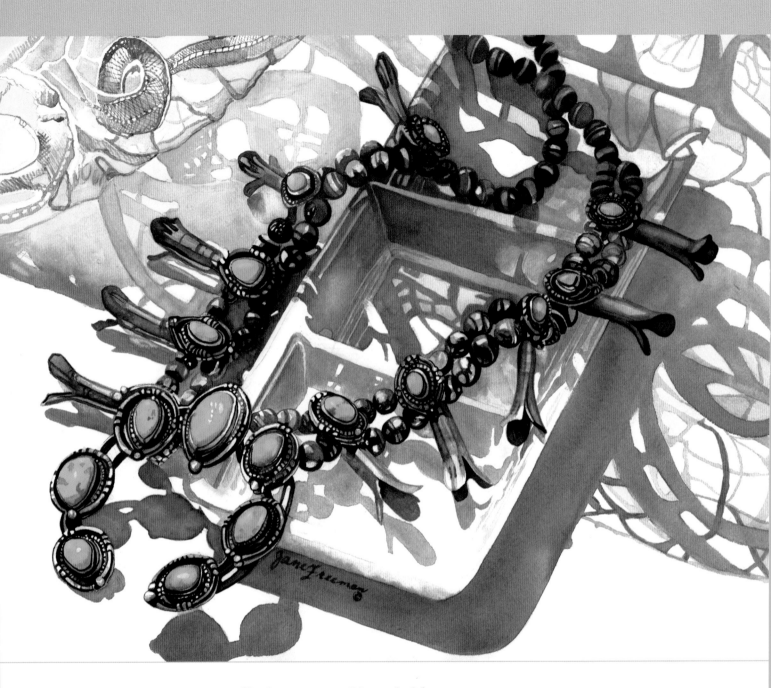

"Have confidence that if
 you have done a little thing well,
you can do a bigger thing well, too."

—Joseph Storey

CREATING BACKGROUNDS

How many times have you developed your main subject, and then everything came to a standstill because you couldn't decide what to put in the background? Backgrounds are one of the most common problems that all artists must face.

You can circumvent this problem by developing a background in the photography stage, adding a background from another photo, or filling a background with a solid, dark color or organic, multivalued shapes. There are ways to "try on" a background to see if you like it before ever lifting a brush. Gaining confidence in creating backgrounds will give you greater success in your work and can even lead to a breakthrough in establishing a style all your own. The background can be the backbone of a painting, giving greater depth and excitement to your work.

Vivid Shadows Enliven a White Background
Since the background is white, the key to this painting's success is the incorporation of strong, colorful shadows to describe more clearly the white porcelain dish the necklace is on. The shadows move the eye through the composition and repeat the pattern of the squash blossom necklace, giving unity and weight to the painting.

Ancient Shadows
Watercolor on cold-pressed paper
11" x 15" (28cm x 38cm)
Private collection

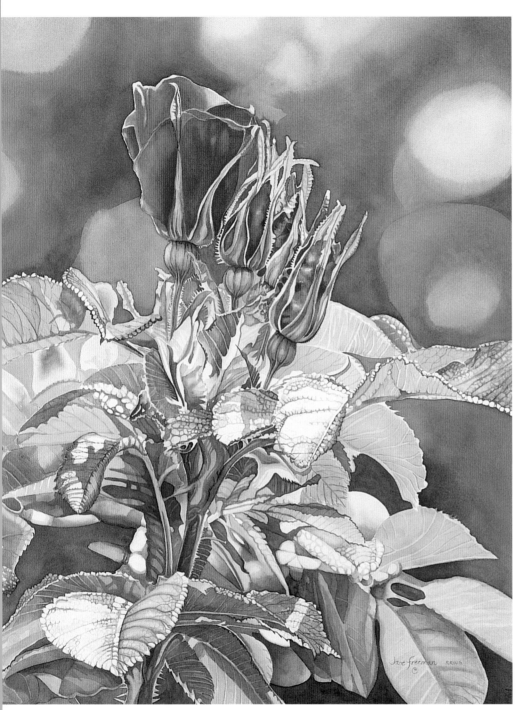

Planning your background can cut your losses and give you more successful paintings. Just knowing ahead of time that your background will work and that you are leaving nothing to chance removes a lot of stress and gives you a boost of confidence to move ahead with your painting.

Knowing what to place in the background of your painting is not always easy, but there are ways to plan backgrounds that can make your paintings more successful:

Set up a still-life arrangement with several different backgrounds. Photograph your options and see which background works best or what you need to change to make it work.

Consider anything and everything as potential background material. Stack wooden boxes, drape fabric, tape a curtain to the wall to pretend there is a window, or just place a fireplace screen behind your subject. No doubt you will find countless items in your home that you never thought of as background material.

Think in terms of colors, textures and contrasts. It is not necessarily the background items themselves that matter, but the qualities they have that can support your subject.

Keep a photo file of material related to your favorite subjects. If you paint flowers, spend time photographing fences, gates, arbors, benches, urns or flowerpots that might work well in your background.

Cut and paste to test. Piece together photocopies of your photographed subject and potential background elements to see what works.

For simple backgrounds, test colors. Once your subject is painted, hold color swatches, paint chips or even colored magazine pages beside the subject to compare color choices.

Planned, Yet Simple
Rather than having a solid blue sky as my background, I chose to use the circle pattern I could faintly see in my reference photo. (The background I photographed is actually a lake.) This made the piece more interesting and gave it a sense of atmosphere.

Dakota Morning
Watercolor on cold-pressed paper
26" x 20" (66cm x 51cm)
Collection of the artist

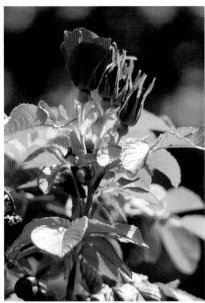

Reference Photo
The background here is water. When I snapped the picture, these circles appeared. I re-created them for *Dakota Morning*.

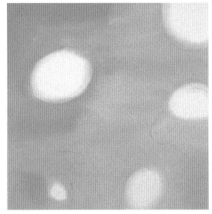

1 Apply the First Wash
Apply a pale wash of Phthalo Turquoise on a water-primed surface, saving white for the circles. It's not necessary to make the wash entirely uniform in value. For this wash and each one to come, keep the paper completely flat so the paint won't shift, and allow it to dry flat.

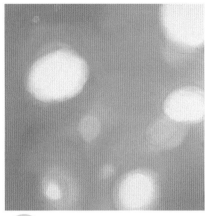

2 Carefully Darken
When this is completely dry, prime the paper again and apply a second wash of the same color, leaving the white circles and a ring of your first wash around them. Working quickly in a circular motion, wipe back the color with a thirsty brush to keep it from moving into your lighter first-wash rings. Keeping the entire surface wet as you work keeps the edges soft.

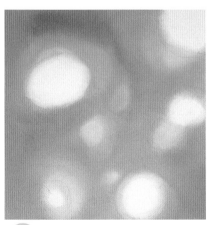

3 Protect Previous Washes
Apply a third wash, keeping it away even a little more from the lighter areas already established. Again, work with a thirsty brush to pull back the pigment, keeping the lighter areas free of paint.

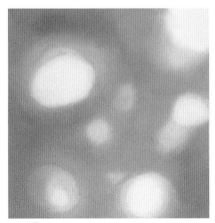

4 Build Depth
Darken the background with yet another wash of color, leaving some areas lighter to build depth.

Taking It One Step Further
Adding a color such as New Gamboge could create a glowing effect appropriate for night-time streetlights or candles, perhaps. However, watch how you apply it. The circle on the lower left shows the yellow laid in too bright, making it abrasive and too obvious. The circle on the right shows a very light application of color into a primed area for a soft glow. The circle in the upper-left corner shows where the priming water went into the blue and carried some of the yellow into that area, giving it a greenish cast.

The only time I would consider coming up with an unplanned background is when that background is going to be a solid color or an abstract, organic one. Then you can develop a background without preplanning it.

Even when you don't predetermine how you will approach your background, take the time when you do get to the background to make some educated choices:

Repeat some of the subject's colors (or similar ones) in the background. This will help unify the painting. Color repetition is especially important when you're creating an organic, out-of-focus, multicolor backdrop for your subject.

Consider the contrasts involved. Think about where you need contrasting colors or values to accent your center of interest.

Plan the placement of background colors and values. Study your painting for a while to see where you might need some darks against light edges or vice versa, and perhaps make note of these on a piece of paper. This way, even when you must work quickly as you paint the background, you will be confident in your choices.

Simplification Supports the Subject

In the original scene, many tiger lilies were behind the two main flowers. Soft-edged shapes suggest more flowers without being obtrusive. Repeating the main flower colors in the background creates unity. Pinks of similar values add variety without being distracting, while green areas offer just enough complementary color.

I did not paint this background haphazardly even though it was not preplanned. I thought about where I needed lights and darks. Placing the lightest light behind the butterfly's head draws the eye to that focal point.

Monarch Mystery
Watercolor on cold-pressed paper
29" x 21" (74cm x 53cm)
Collection of Merit Care Hospital

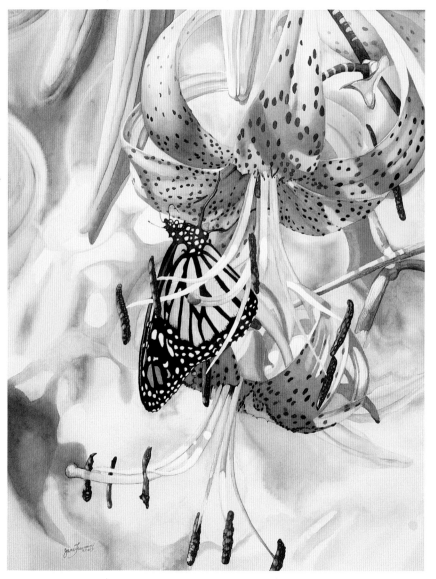

You might find that a detailed background will best support your subject. A detailed background can give a subject context, furthering the story or message you're trying to share. The background could even be the real story, providing enough interest to make the viewer care about your subject. Maybe a detailed effort can just give you a chance to break from the norm if you typically keep your backgrounds simple.

A detailed background requires careful planning and drawing before you start painting. If you do not have clear guidelines to follow, chances are the details will be inaccurate and you could ruin your painting. A few suggestions:

Plan as much as you can with your camera. If you can get the elements positioned as you want them in your photos, you will save a lot of time that otherwise would be spent composing. This takes practice and forethought, however. The more you work this way, the easier and more natural it will become.

Use background detail to lead the eye. Place the colors, values, shapes or textures surrounding the subject in a way that guides the eye to the area of the subject you want it to focus on.

Glaze if you've gone too far. Sometimes it is hard to know when you have too much going on in the background. If you decide after it is painted that you've gone too far, it is easy to push areas back with glazes to simplify the background until you feel it works.

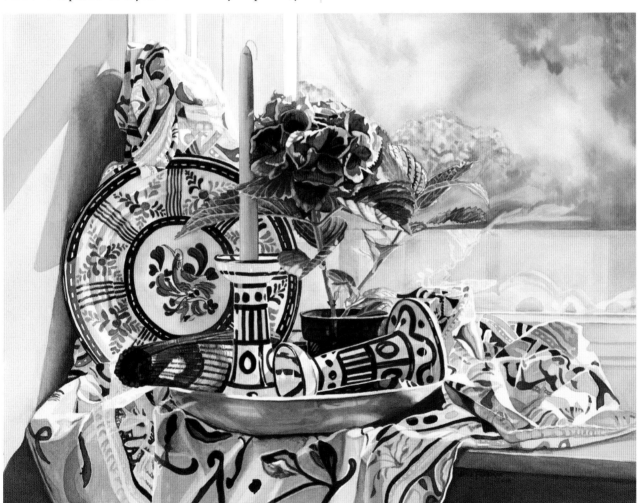

A Detailed But Soft and Diffused Background
The soft reflections on the background window contrast nicely with the hard edges of the fabric, dishes and plant. It might have worked better if I had darkened the window frame, adding some stronger directional lines, but overall it is a suitable setting that doesn't overwhelm the center of interest. Repeating the yellows in the tablecloth and dishes for the shadows on the left wall creates a warm glow that provides interesting shapes and suggests strong late-afternoon light.

Memories of Jeri
Watercolor on cold-pressed paper
14" x 19" (36cm x 48cm)

Marilyn, what inspired such an unusual subject and perspective for *Sea Turtles of Kahalu'u*?

I was inspired to create this painting after a wonderful experience of snorkeling in one of Hawaii's beautiful bays, joined by several large sea turtles. I had my underwater camera with me. To get a shot close enough to show this much detail, I had to wait for a turtle to swim toward me. My goal was for viewers to feel like they were having a similar experience to what I was enjoying.

The perspective of the nearby turtle, which appears to be swimming toward the viewer, made it an ideal focal point for the composition. It is counterbalanced by a more distant turtle in the background. To make the painting look more three-dimensional, I put most of the detail in the large turtle, emphasizing that it is closer to the viewer. The other turtle looks much farther away due to its smaller size, lack of detail and less intense color.

One really feels underwater in this painting. What was most critical to creating that feeling?

Most important in creating the feeling of being underwater is the gradation in color and value of the water. The darkest and most intense colors are at the top and fade toward the bottom, which is the area closest to the viewer. Achieving this effect required many layers of light washes of various blues, applying more color at the top than at the bottom and allowing the paint to dry completely between layers, so as not to lift the layer below.

Did you paint the turtles first, then paint around them to form the background?

I enlarged my reference photos on a photocopier to the size I wanted the turtles to be in the painting. I then drew an outline of each turtle on separate sheets of tracing paper and experimented with where to place them on my watercolor paper. This step helped tremendously with getting the composition

Marilyn Wear worked as an advertising artist and illustrator before pursuing painting full time in 2003. Her work won immediate recognition, winning awards in juried shows around the country. In 2005 she became a signature member of the National Watercolor Society. Marilyn is currently represented by First Street Gallery in Turlock, California.

Sea Turtles of Kahalu'u
Marilyn Wear
Watercolor
19" x 26" (48cm x 66cm)
Collection of Desiree Leonard

and perspective right. I then transferred the turtle outlines to my watercolor paper and filled the area inside each with masking fluid. Then I was free to do my multilayered background without worrying about having to paint around the edges of the turtles.

With such a complex background, where did you start?

I first created a textured, sandy-looking bottom by mixing together a small amount of Cerulean Blue and Raw Umber Violet with a larger amount of Buff Titanium and a generous amount of water so that the paint stayed wet while I sprinkled coarse salt on it. The salt causes the paint to separate and dry into interesting patterns that look very much like grains of sand. I added this texture only at the bottom of the painting because less detail in the background creates a feeling of distance. After that was completely dry, I scraped off the salt and started my layers of light washes of blue.

How did you achieve such realistic water?

Getting the water to glow required using four different blues in several pale layers. I started each layer with a light wash of clear water, then went over that with a layer of blue, applying the most color at the top and fading to clear toward the bottom. To keep the color smooth, I applied the color to the top part of the painting and blended it toward the bottom with the large clear-water brush. After this dried completely, I repeated the process with a different blue until all four blues had been applied, then started over again in the same order. The blues I used are Cobalt Teal Blue, Cerulean Blue, Prussian Blue (sparingly, because it is intense) and Ultramarine Blue. Before I applied the last two layers, I removed the masking from the background turtle so that it would receive a couple of the blue layers to further push it into the background.

How did you handle all the detail shown underwater?

When the last background wash was completely dry, I painted the background rocks

and coral, making them less detailed in the background and more detailed toward the foreground. I simplified these shapes so as not to detract from the main subject, but included enough detail so they would be recognized as coral and rock. I then removed the masking from the foreground turtle and drew just enough detail lightly in pencil to give me reference areas to fill in the rest of the detail with my brush. Working a small section at a time makes this easier to do accurately.

I used the same colors on the background turtle as for the main turtle, but it looks darker and more distant because of the two underlayers of blues. After it was completely dry, I softened the edges and pushed it more into the background by going over it with another light wash of water followed by a light wash of blue.

Marilyn's Background Tips

- For a three-dimensional effect, create a blurred background to emphasize a detailed subject or foreground. Protect your subject either by painting around it or applying masking fluid. Then dampen your paper with water and let it dry a little while you mix a few different colors that will harmonize with your foreground colors. Apply the background colors to the dampened paper so that the edges blur slightly into each other.

- Whether your background is in focus or blurred, always repeat at least one of the colors from your foreground in your background to create unity. For example, if your background is a blue sky, don't apply blue only; glaze it with some of the colors in your foreground.

- If you opt for a rich black background rather than a detailed one, mix your own black using the dominant colors of your subject. Mixing colors already in your painting will better harmonize the background with the rest of your painting,

Fixing a Troubled Background

Before

Marilyn had planned a composition where the birds are the main focus, and their heads add to the interest of the composition by forming a triangle. She didn't notice until the painting was nearly finished that the background branch just below the dominant bird bisects the triangle the birds were forming, creating an unwanted distraction. Also, the bright leaves in the background overwhelm the birds. The overall effect is a flat composition with no main focus.

After

Marilyn covered the distracting branch with a black mixed from red and green so that it would harmonize with the scene's reds and greens. She darkened the leaves behind the dominant bird so that it would stand out. Now the viewer sees the dominant bird first, and the triangle formed with the other two birds and their supporting branches is clearer. The changes add dimension and push the brightly colored birds forward.

Tropical Trio
Marilyn Wear
Watercolor
11" x 16" (28cm x 41cm)

Simple backgrounds of solid-dark or variegated color naturally draw attention to a painting because they usually create high value or textural contrast with the subject matter.

Backing your subject with a solid dark creates a richness that has dramatic effect. This is a particularly good choice for floral and still-life paintings because:

- it isolates the subject and moves it forward toward the viewer's eye
- it can help emphasize and define your subject
- its simplicity supports the subject without competing with it
- it is relatively easy and quick to do

A background of variegated, organic shapes may not be as dramatically dark, but its multiple values can:

- create movement and interest
- emphasize individual areas of the subject
- help guide the eye around the painting with carefully placed lights and darks
- offer information about the subject or situation

A Background That Supports Without Interfering
A solid-dark background allows you to blend the dark over some edges of your subject to immerse them into the background and make them disappear, which is an interesting effect. I did this with the radish leaves here, which gives a feeling of depth and helps to describe the light or lack thereof.

To Your Health
Watercolor on cold-pressed paper
19" x 15" (48cm x 38cm)

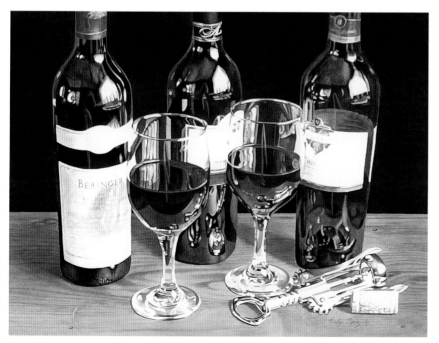

Cindy Agan, a self-taught and internationally published watercolor and portrait artist, is the author of the book and video titled *Painting Watercolors That Sparkle With Life*. Her work also appears in the *Painter's Quick Reference* series and *Drawing and Painting People: The Essential Guide*. Her studio is in South Bend, Indiana. Visit her website at www.cindyaganart.com.

Cindy, how did you light and set up the reference for *Three Cheers*?

I used natural light from a large picture window, setting the wine bottles, glasses, corkscrew and cork on a small wooden table to the left of the window. I wanted some blue reflections in the glass, but the sky was rather gray that day, so I draped a blue cloth over a quilt rack and onto the floor directly under the window.

Using a digital camera, I took several photos at different angles and depths, checked them on the computer screen and printed the best one to use as my reference. I kept the wine bottles in my studio to study the glass color and clearly see the details in the labels.

How did you save your whites?

I carefully painted around the lightest areas, but did use fluid acrylics to touch up any details that were inadvertently covered up or too tedious to paint around.

You really have some gorgeous darks! Explain your process.

Wanting to achieve deep, dark values is what first prompted me to incorporate the fluid acrylics into my watercolor paintings. Painting several glazes of watercolor for this background was proving much too slow a process for this project, which had a deadline. Using Golden fluid acrylics, I mixed Burnt Sienna and Carbon Black and applied fifteen to twenty transparent glazes, just as I would watercolor. The same principles applied, but the brilliant coverage of the acrylics allowed me much more freedom without the worry of lifting the pigment. If I applied the paint too thickly, the acrylics did appear glossy, so I simply added Golden matte medium to the paint and glazed over the area to dull the shine. With the dark background in place, I decided to deepen the values in the wine bottle and glasses. It was apparent that the deeper I pushed the darks, the more the highlights sparkled.

Three Cheers
Cindy Agan
Watermedia on Crescent museum mat board
23" x 31" (58cm x 79cm)

Cindy's Background Tips

- In order for the background to support the focal point, first determine the areas of importance that need to be developed. Change or eliminate elements that detract from your subject.

- Evaluate each painting individually when deciding how elaborate to make a background. Each work will have its own unique set of problems and assets that will affect your decision.

- If you paint the details you find in the background, don't paint every one. Give the viewer's eyes a chance to rest.

"A painter shows you what he painted,
 but an artist shows you why he painted."

—Unknown

PAINTING PRACTICE

Time to put your watercolor and compositional skills to the test. Nine short mini-demonstrations, each re-creating a section of a painting presented in the book, help you face the challenges of portraying individual textures such as reflective silver, woodgrain, delicate flower petals and gemstones. Five longer demonstrations cover additional textures and show you how to combine a variety of textures in a strong, light-appropriate composition.

The Biggest Challenge
The hardest part of the painting was trying to create a smooth background without going over the bowl's edges. Each wash had to be done quickly and in one pass. Mixing enough background color ahead of time was critical. There could be no stopping in the middle to make more.

A Slice of Summer
Watercolor on cold-pressed paper
20" x 29" (51cm x 74cm)

bring lace to life with colorful shadows

For *Eggsactly Right*, shown on page 23, I chose a view from above that would show off the entire piece of my grandmother's lace. Success hinged upon linking the shadows to move the eye through the painting and capturing the glow in the eggs. I exaggerated the colors in the lace to create the appearance of light bouncing around. The very colorful shadows create excitement in an otherwise subdued painting. They attract instant attention and draw the eye to the center of interest, making the largely white eggs pop.

Materials

Palette
French Ultramarine
Moonglow
New Gamboge
Quinacridone Gold
Quinacridone Rose
Raw Umber Violet
Brushes
Round: nos. 2, 8, 10
Paper
300-lb. (640gsm) cold-pressed

1 Draw as You Go
Draw the lace detail only in the area that you plan to paint at that time. This way you will avoid smearing the graphite into areas of white that you want to remain very clean. Get the lace hole shapes correct; they tell the viewer what kind of lace this is. Show some of the irregular stitches and shapes that result when something is handmade: they help to tell the story of the lace.

2 Fill In the Holes and Begin the Eggs
Paint the holes with Moonglow. The pigment will separate a little, giving some texture or suggestion of the surface below. Once you've painted a few holes, stop and erase the lines so you do not smudge the graphite into clean areas. Continue painting the lace this way to keep your paper clean. Prime the eggs with water and a bigger round, such as a no. 10. Stay within the edges to keep them crisp. Then use a no. 8 round to apply a light New Gamboge wash. Quickly blot with tissue any paint that moves into areas of the eggs that need to remain white. Once the first wash dries, prime the entire egg again and add a thin glaze of Quinacridone Rose to some areas.

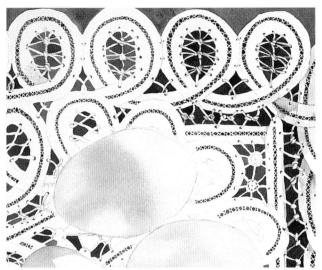

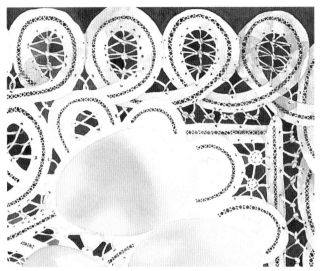

3 Build the Eggs With Thin Glazes

For now, hold off doing the lace closest to the eggs. The slightest amount of water from priming the eggs could agitate the Moonglow (from the lace holes) and ruin the eggs' crisp edges. Apply a Moonglow glaze to the eggs, and, once that is dry, add glazes of New Gamboge and then Quinacridone Rose. If you're preserving those whites and glazing thinly, your eggs should begin to glow. Darken the lace holes with a Raw Umber Violet glaze, which also gives them more of a warm glow.

4 Shade the Lace

Continue to glaze Raw Umber Violet on the holes. While this is drying, place another coat of Quinacridone Rose and Moonglow on the eggs. When the holes are dry, begin shading the lace, using Quinacridone Gold, French Ultramarine, Quinacridone Rose and Moonglow. To paint the shadow side of some of the fine threads on the lace, use a no. 2 round. Have fun exaggerating the colors and truly making the painting your own.

5 Finish the Lace Nearest to the Eggs

Add another glaze of color to the eggs if needed. When you feel they're done, draw and paint the remaining lace closest to the eggs. Shade very carefully up to the eggs so you maintain their edges.

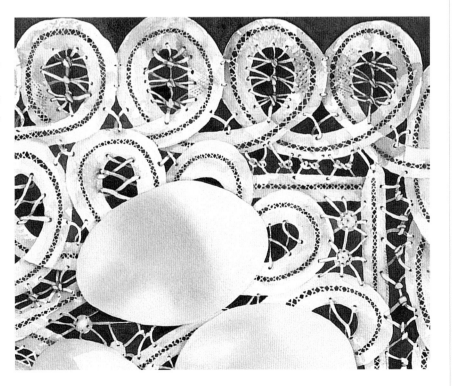

show, then suggest the texture of crocheted lace

In *Repose* (on page 61) are very strong directional lines created by the flower stems, lace, the edges on the table and the pillow fringe. They all move the eye up toward the sharp contrast of the white flowers against the dark background.

We tend to read a painting from left to right just as we read a book, so the fringe on the left is made detailed enough to draw the eye from that edge into the painting. The lace is less detailed on the right side because I do not want the eye to go there and then exit the painting. Sometimes there is only a suggestion of lace in the shadows. Showing just the texture of lace is enough to make the eye read it as lace. The background is merely hinted at, keeping it informative but not distracting.

Materials

Palette
New Gamboge
Permanent Brown
Phthalo Blue (Green Shade)
Quinacridone Burnt Orange
Quinacridone Gold
Quinacridone Rose
Sap Green
Transparent Brown Oxide
Brushes
Round: no. 8
Scrubber: one flat, one small round
Paper
300-lb. (640gsm) cold-pressed

Establish the Lace

Make the drawing, then lay in a light wash of Transparent Brown Oxide for the chest and the lace holes. This first wash will establish most of your lace and background; then all you have to do is decide how dark or detailed you want certain areas to be as you proceed. Holes of varying values rather than a uniform flat brown will create a more realistic look. Once this is dry, further establish the holes with a second light wash, keeping their shapes irregular and interesting. Define the lace in the lightest area with some linework using Transparent Brown Oxide.

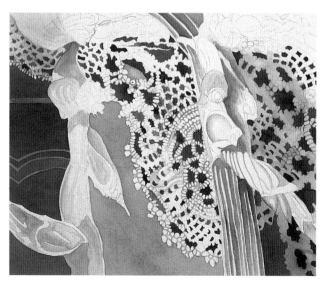

Define the Surrounding Area

The green stems will help you define the edges next to the lace where the cast shadows will be. Use Sap Green to create the shapes in the stems and veins, leaving a lot of whites for nice, clean highlights. Apply a soft wash of Transparent Brown Oxide over the lace areas on the right, which are going into shadow.

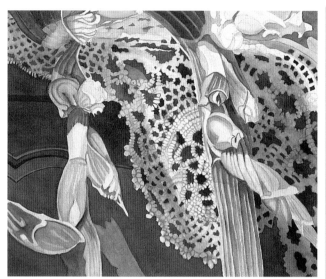

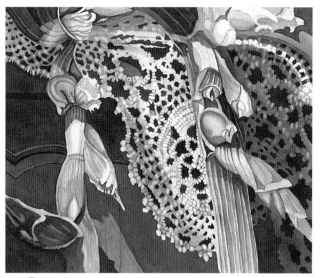

3 Values Give Shape

Darken some of the shadowed greens by mixing a little Phthalo Blue with Sap Green. Gently wash New Gamboge over the veins and areas where you see yellow, but let some of the brightest areas remain pure white. Giving good dimension to the floral stems will make them appear to sit on top of the lace in a realistic way. Define more of the lace with fine linework. Ovals and circular shapes represent well the lumpy quality of crocheted lace.

Lay in some gentle washes of Quinacridone Gold, Permanent Brown and Quinacridone Burnt Orange in the shadows of the lace for interest and the feeling of reflected color. If it appears drab, wet the entire area in shadow and drop in a little Quinacridone Rose. Apply another coat of Transparent Brown Oxide to the chest and some of the lace holes. Continue building up the greens in the stems to define their shapes. To recover a lost vein, simply wait until the area is dry and lift it out with a flat, damp scrubber brush. Work gently and tap dry with a tissue.

4 Push Your Colors

Decide how deep to make the values to achieve the look you're after. Study each area to decide where you need to strengthen shadows. Deeper shadows make the light areas pop out more, giving greater depth. Check that your lace holes are dark enough yet still retain some variety in value. Darken the holes on the right side again and strengthen the shadow on that side as well.

Lift some color out of the lace to show texture in the shadowed areas. Don't make it look too busy by doing too much. With a small, round, damp scrubber brush, gently scrub in a circular motion and blot. Repeat until you have a soft, lighter circular area, then create another area next to it. Place these lightened circular patterns so they follow the lace pattern you have established. This will be enough to convey the lace texture without excessive detail, which can be very interesting in the shadows. It takes just a few to give the impression of lace. Add more lace detail until you are satisfied. Stand back often before making any adjustments so that you do not do too much or overwork an area.

use strong reflections to make silver shine

Silver requires great dark grays and blacks. For *Zelda's Zinnias* (on page 25), Neutral Tint is used to capture these darks. This particular transparent pigment seems to mix well with other colors to gray them down. Usually I work with a limited palette, but here I used quite a few different paints. The colors look cohesive rather than chaotic, however, because they are repeated in the teapot's reflection on the silver platter. This repetition, coupled with the repeated shapes in the reflection, creates unity.

Materials

Palette
Anthraquinoid Red
Indanthrone Blue
Neutral Tint (M. Graham & Co.)
New Gamboge
Permanent Brown
Perylene Red
Perylene Scarlet
Quinacridone Burnt Orange
Quinacridone Gold
Quinacridone Rose
Quinacridone Sienna
Sap Green
Transparent Brown Oxide
Brushes
Round: nos. 6, 8, 24
Paper
300-lb. (640gsm) cold-pressed

1 Draw Selectively and Lay In Local Color

A good drawing outlines all the major shapes, but with such a busy scene, it's better to save some drawing for later so you don't risk smearing graphite on the paper. In the reflected areas, draw some of the shapes with your brush as you go. Lay in local color, including Quinacridone Sienna, Transparent Brown Oxide, New Gamboge and Sap Green, for some of the major shapes. This will also help you determine if your teapot looks accurate or if you need to make some adjustments in your drawing. Use a soft gray (Quinacridone Rose plus Neutral Tint) to finish some of these shapes.

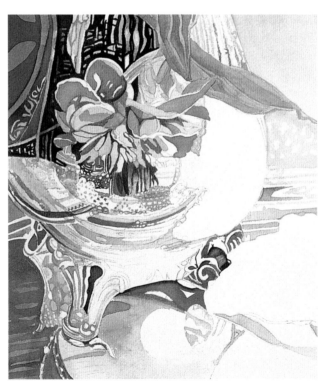

2 Add Deeper Color

Slowly build up the zinnia with various reds for rich, multidimensional color. Begin with soft washes of Perylene Scarlet, Anthraquinoid Red and Perylene Red to set up the shapes and base colors. By adding some Permanent Brown or Transparent Brown Oxide to your red it will become darker and richer; do this later when you need to deepen a red for the shadows. If you were to use a heavy red immediately, you would not achieve the glow of those under-colors coming through. Throughout the painting you will be glazing with these reds, Quinacridone Burnt Orange and Quinacridone Rose, to deepen the color.

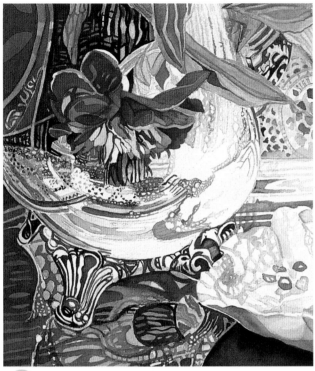

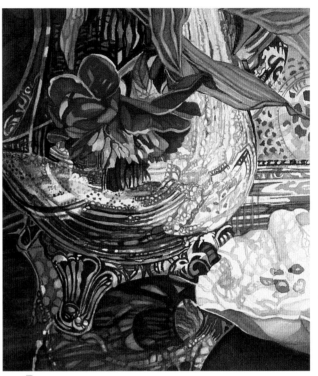

3 Develop Shapes and Details

Softly wash in the abstract shapes of the cast shadows under the teapot with Neutral Tint. A wash of Quinacridone Rose or Quinacridone Sienna will add color to some of these shapes. Use Transparent Brown Oxide on some of the lower shapes. The small dish is a mixture of New Gamboge with Transparent Brown Oxide in a light wash to show the shadowing. This dish has hand-painted ladybugs and leaves in the bottom, so wash in Perylene Red and Sap Green.

At first I wasn't going to paint the lace behind the teapot as shown in the original painting for this particular demo, so I started placing a wash in the background. But, then I realized the importance of showing the lace because it is reflected on the teapot. The white of the paper was lost as a result of the wash, but you can begin to wash in the lace holes you've drawn with Transparent Brown Oxide. Get a general idea of the lace pattern and the direction you want it to go on the teapot, then draw it with your brush and a pale mixture of browns and blues. Darken the green in the upper leaves by adding Indanthrone Blue to Sap Green. Once your patterns and colors are established, you can easily add another layer of the same colors to define and darken those shapes better.

4 Deepen and Darken

Draw lines and shapes that follow the bottom curve of the teapot. You want this area to show the reflections from the surface below because it is bowed there. Glaze with Quinacridone Rose, Quinacridone Sienna and Transparent Brown Oxide for a luminous effect. Add the colors reflected in the platter by glazing with the same colors used above it. Apply a light wash of Indanthrone Blue to dull some of the whites there.

Finish developing the lace pattern on the side of the teapot with Transparent Brown Oxide. Add another coat of Transparent Brown Oxide to the lace holes behind the teapot, and use the brown to deepen the shadows in the dish as well. Apply several more washes of the reds and yellow used before to deepen the values of the zinnia. Darken the leaves with the same green mixtures used previously. Use glazes of Quinacridone Gold on the leaf to brighten it and define some of the veins more. Add washes of Quinacridone Gold to a few areas inside the little dish and mostly under the dish to show reflected light. Glaze with any of the Quinacridone colors already used to liven up areas that are dull or not colorful enough.

get gold's glimmer by mirroring the surroundings

Gold, as in *Golden Anniversary* (on page 5), is similar to silver in that it is highly reflective and mirrors surrounding objects. Painting it can create some very interesting and complex still-life arrangements. Gold can also take on the color from neighboring objects, like the inside of this cup, which reflects the blue-green color of something out of view. This quality can be useful, so be aware of this nice feature when you are painting your own arrangements. Adding reflected color this way can add a lot of interest to a painting.

Materials

Palette
Carbazole Violet
Indanthrone Blue
New Gamboge
Permanent Brown
Phthalo Turquoise
Quinacridone Burnt Orange
Quinacridone Gold
Quinacridone Rose
Sap Green
Transparent Brown Oxide
Brushes
Round: nos. 4, 8, 24
Paper
300-lb. (640gsm) cold-pressed

1 Start Light

Draw your cup and vase so they are correct in shape. This cup is actually a creamer that has a square side under the handle, a form that may be hard to convey without it seeming distorted at the top. Draw the shape carefully. Be equally careful as you draw the lace pattern reflected on the cup.

Apply a thin wash of New Gamboge on the vase. Paint a light wash of Transparent Brown Oxide mixed with Quinacridone Burnt Orange on the lace shapes in the cup and on the vase, leaving areas of yellow showing through on the vase. Use Transparent Brown Oxide to find the tops of the gold acorns. Place a light wash of Carbazole Violet mixed with Phthalo Turquoise on the background. Paint the purple areas on the cup with Carbazole Violet plus a little Indanthrone Blue. Place a light wash of Phthalo Turquoise inside the cup to find the shapes.

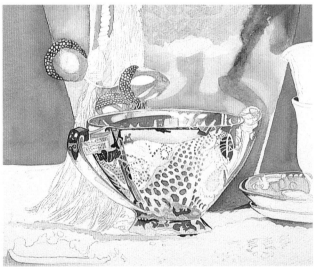

2 Build Washes

Further develop the lace reflected on the cup. Develop the inside of the cup with teal (Phthalo Turquoise plus a little Sap Green). Apply different shapes of Quinacridone Burnt Orange, Transparent Brown Oxide, Quinacridone Gold and Permanent Brown on the vase to begin a textured look. Use these same colors in the gold acorns. Outline the tops of each acorn with Transparent Brown Oxide plus Permanent Brown. Apply another wash of Carbazole Violet plus Phthalo Turquoise on the background, dropping some Quinacridone Rose onto the lower-left side for interest.

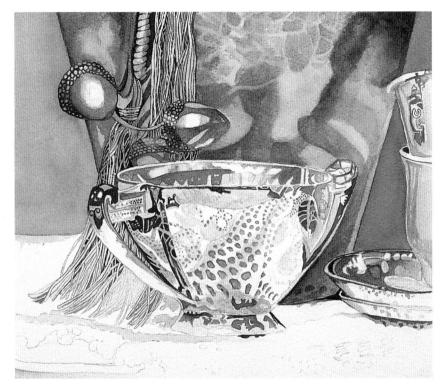

3 Go for Deep, Rich Color

Draw the individual tassel strings. Use Carbazole Violet mixed with Indanthrone Blue to fill in the areas between the tassels on the shadowed side, and Transparent Brown Oxide on the sunlit side. Use the blue-violet mixture to shade the side of the vase and the rope sides, and to deepen the purple in the cup.

Apply a wash of New Gamboge plus Quinacridone Gold over the entire vase to strengthen its gold hue. Create some interesting shapes in the vase to give texture to the surface. Darken these shapes with more glazes of browns and golds, aiming for rich color. This may take four to six coats, depending on how light your washes are. Once everything is dry, add another wash of Quinacridone Gold for glow. Remember to let the paper dry completely between coats. If it feels slightly cool, it is still wet.

4 Go Deeper

Enrich the background with another wash of the Carbazole Violet-Phthalo Turquoise mixture. Continue building up colors in all the other areas to the values they need to be. Finish the tassel bottom; when it's dry, glaze over areas of the tassel with Carbazole Violet to create shadows. This will dilute any Transparent Brown Oxide areas, so you will have to repaint them to make them their darkest. Check the values of the lace reflected in the cup; strengthen colors there to make it sharp. Deepen the shadows under the cup and vase with your Carbazole Violet-Indanthrone Blue mixture.

Create the pattern in the lace tablecloth with Transparent Brown Oxide and Quinacridone Burnt Orange, and use those colors to develop the table reflections in the lower-left corner. For darker browns, add some Indanthrone Blue.

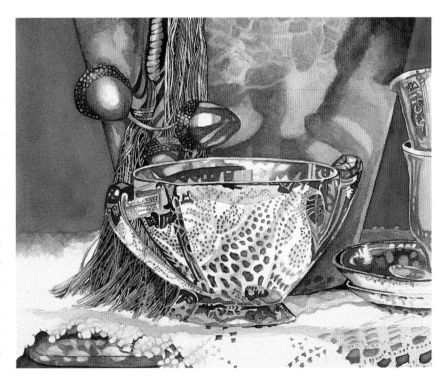

This demonstration shows how a simple background of shadows can support the subject, which in this case is a squash blossom necklace of my mother's. (See the complete painting on page 70.) The necklace lies on a white porcelain dish and is depicted simply by the shadows it casts. These simple shadows ground the jewelry so it doesn't appear to float on the paper, but rather drapes heavily across the dish. Dimensional washes, carefully saved highlights and delicate linework describe the turquoise stones and the silver beads and squash blossom flutes of the necklace.

Materials

Palette
Burnt Sienna
Cobalt Teal Blue
Indanthrone Blue
Moonglow
Payne's Gray
Phthalo Blue (Green Shade)
Phthalo Turquoise
Quinacridone Rose
Brushes
Round: nos. 2, 8
Paper
300-lb. (640gsm) cold-pressed

1 Place Colorful Shadows

Prime the area of shadow cast from the dish with water, then apply a wash of Moonglow. The wash should have more pigment along the edge where it meets the dish to make that area darker, appearing as if it is under the lip of the dish. Prime and add a Moonglow wash for the shadows under the necklace as well. While the color is still damp, place a small amount of Cobalt Teal Blue in the upper shadows to suggest a reflection from the turquoise stones, and drop a small amount of Quinacridone Rose into the wash below the necklace to warm up that area. Apply a light wash of Cobalt Teal Blue on the stones, and use Payne's Gray to begin forming some of the beads and metal of the necklace.

2 Develop the Necklace

Deepen the shadows slightly with a second wash. Build up the turquoise stones with more Cobalt Teal Blue and Phthalo Turquoise in the darker areas. Leave white where the stones and beads reflect light. Develop the metal with shades of Payne's Gray. Create the darkest (near-black) gray with a mixture of Phthalo Blue, Indanthrone Blue and Payne's Gray. Paint a glaze of Phthalo Turquoise on the inside of the squash blossoms (over the dried wash of Payne's Gray).

3 Add Reflected Color and Detail

Wash Cobalt Teal Blue over some areas of metal where the turquoise stones are reflecting, and add a wash of Quinacridone Rose in a few areas to suggest warm reflections. Apply Burnt Sienna to the squash blossoms and some of the beads to show some aging from tarnish. With the near-black mixture from step 2, deepen the lines in the silver and finish the detailing around the beads.

make a map to depict smooth glass

Glass is easy to paint when you:

- realize it is merely a group of abstract shapes
- enlarge your reference photo so you can see the shapes
- make a careful drawing to record these shapes
- supply colors around the glass so those colors can pass through or reflect in the glass, helping to define the shapes

In *Sundaes on Padre* (on page 54), the shells in the glasses add color, shape and interest. A dark area behind the glasses helps to define some other shapes more clearly. When all these shapes combine, they read "glass" like magic!

Materials

Palette
Indanthrone Blue
Permanent Brown
Phthalo Green (Blue Shade)
Quinacridone Burnt Orange
Quinacridone Gold
Quinacridone Rose
Quinacridone Sienna
Transparent Brown Oxide
Brushes
Round: nos. 4, 8
Scrubber
Paper
300-lb. (640gsm) cold-pressed

1 Lay In Local Color

After drawing all the shapes, begin painting them with light washes of local color. Mix a little Indanthrone Blue with Transparent Brown Oxide for the dark brown background. The darker blue-gray is just more blue than brown; lighter blue areas are Phthalo Green.

2 Map the Shapes

Continuing to find shapes that are accurate is essential for the glasses read correctly. Lightly draw additional shapes in the glasses and check that those already drawn look right. If they look confusing to you, they will confuse the viewer. Find and begin to define the shell shapes with light glazes of Quinacridone Burnt Orange or Transparent Brown Oxide. Once this is dry, glaze on more coats of the same color or a coat of Quinacridone Gold or Quinacridone Sienna to make them glow. Begin making the dark background less drab by applying a Permanent Brown wash.

3 Build With a Variety of Colors

By slowly building up color, you can have soft and hard edges, which is important in portraying glass. Combine Phthalo Green with Indanthrone Blue to get a darker blue for areas needing that. A variety of blues makes the glass more interesting.

Keep developing the values of the shells. If you lose some light areas in the shells, lift color with a scrubber brush. The light coming through under the shells helps to set up a glow. Saving pure paper for special areas like this is essential for clean color.

4 Create Contrasts

Deepen all the colors in the lower shells with Transparent Brown Oxide, Quinacridone Gold, Quinacridone Sienna and Permanent Brown, making them appear to glow. A wash of Quinacridone Rose can help some areas of brown in the shells glow as well. Do the same thing with the glass, darkening areas for more contrasts. Strong color gives a sharp contrast with the white of the paper, which helps to convey the sense of light passing through the glasses.

Clean up edges and make sure nothing looks confusing. It's easy to lose edges on glass rims and not be able to see where one piece of glass ends and another begins.

create just enough detail for woodgrain

Painting woodgrain can be as easy as hinting at the grain. You can get very detailed if you desire, but it is not necessary. My interpretation of the wood on this birdhouse (from *Glorious Morning*, on page 10) comes across as quite accurate even though details are only suggested. A little detail goes a long way, so don't overdo it.

Materials

Palette
Carbazole Violet
Indanthrone Blue
New Gamboge
Quinacridone Gold
Quinacridone Rose
Quinacridone Sienna
Transparent Brown Oxide
Brushes
Round: nos. 4, 8
Scrubber
Paper
300-lb. (640gsm) cold-pressed

1 Ensure Accurate Angles
A very accurate drawing is necessary so all angles are in correct perspective. Lay down a light wash of Transparent Brown Oxide in the separate shapes you have drawn. Now look again to see if your angles read correctly. If they don't, they will be easy to correct at this stage because the nonstaining, transparent Transparent Brown Oxide lifts easily. Develop the separate shapes to have varying values of brown.

2 Deepen Values
Wash pale New Gamboge over a few areas where sunlight is hitting the wood. Apply several more washes of Transparent Brown Oxide to establish more values. By keeping within each shape you have drawn, you build up the birdhouse as individual boards, which is easier now while you can still see your pencil lines.

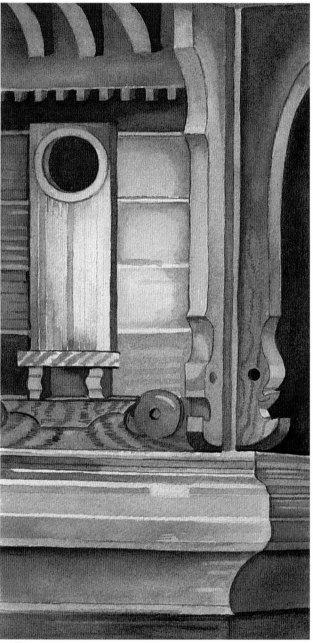

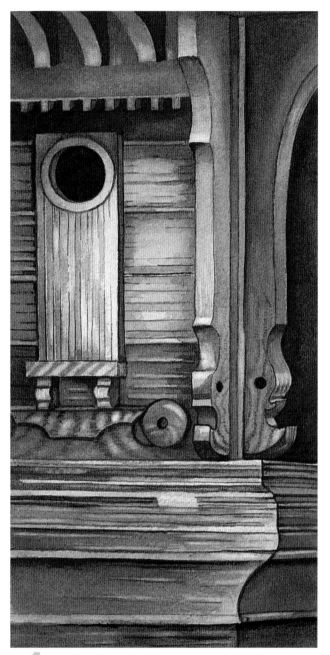

3 Create Texture

The more values you have in this picture—at least eight—the more interesting it will become. Mix Carbazole Violet with Transparent Brown Oxide to make a dark, rich brown for the bird hole, and Indanthrone Blue plus Transparent Brown Oxide for the other deeper shadows. Define some of the wood texture by painting small strokes in a pattern with more Transparent Brown Oxide. These can be merely suggestive or as detailed as you like. Begin defining a few of the small boards on the left by using a scrubber brush to lift paint in straight lines. Once everything is dry, add a glaze of Quinacridone Gold and Quinacridone Sienna to areas where you want light to appear to be bouncing around on the wood.

4 Add Details and Warmth

Add more detail and depth with Transparent Brown Oxide, indicating wood seams or shadows or deepening values again. Then add glazes of Quinacridone Gold and Quinacridone Rose, especially to the ornate corner, to create the effect of warm light flooding in.

incorporate color for white flowers

They may be white, but white flowers can be shaded with any color when you paint them. I've done them using purples, browns, blues and greens, and although each is a white flower in the end, it has a different feel. It all depends on how believable you want your flowers to appear. I am not a total realist in this matter and feel that if your values and shapes are correct, your painting will read as the specific white flower you are trying to depict. However, sticking to colorful grays, including grayed blues or greens, will make a white flower look more natural.

Summer Dream (on page 8) makes good use of interesting negative shapes that are formed by the falls of the iris and high contrast between the flower and the background, giving the painting its strength.

Materials

Palette
Indanthrone Blue
New Gamboge
Permanent Brown
Perylene Red
Phthalo Turquoise
Quinacridone Burnt Orange
Quinacridone Gold
Quinacridone Sienna
Sap Green
Transparent Brown Oxide
Brushes
Round: nos. 4, 8, 24 (largest for background)
Paper
300-lb. (640gsm) cold-pressed

1 Capture Unique Details From the Start

Exaggerate some of the details as you draw them. Pushing the crinkles and bumps in flowers and leaves can make them look more lifelike. Use Transparent Brown Oxide to begin the detail at the base of the bloom, which resembles translucent tissue paper wrapped around the stem just below where the flowers form. This intriguing part of the flower can easily become a center of interest. Carefully paint around the veins in the stems with New Gamboge and Sap Green, defining the shapes in these areas without losing the veins that provide a lot of interest. Wash light New Gamboge onto the background.

Using Perylene Red, wash in some of the shapes on the left side of the flower. Paint some of the shadow shapes in the petals using a grayed lavender (Perylene Red plus a little Indanthrone Blue). Where shadows need to be more red, use more Perylene Red in the mixture, or add a light glaze of this red over the existing gray areas once they are dry. Carefully go around the hairlike projections, which are the beards of the iris.

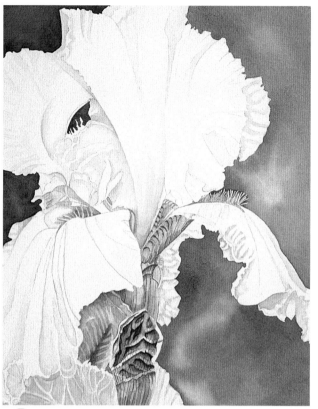

Paint Around for the Background

Use very gentle washes of Phthalo Turquoise mixed with a little Sap Green to further denote the ruffles and shadows in the standard upright petals and the falls. Make it bluer or greener in areas for variety and interest. Keep these edges soft by fading them as you work.

Prime one area of the background and wash in Sap Green, allowing it to meander. Move the color around with a brush and pull it out of certain areas to save selected sections that will later become yellow glows through the darkness. Continue doing this as you paint each of the negative spaces until the background is complete. When you reach the area of background where the beards are, make sure that you've drawn them so you can more easily paint around them, saving the white of the paper so this will be a bright spot. Always keep your paper flat when painting this way, and dry it flat so the paint doesn't move.

Add Color for Definition and Glow

Continue to define and fine-tune the flower's ruffles and shadows with additional (yet still very light) washes of the same colors.

For the darker greens in the stem work, mix a little Indanthrone Blue with Sap Green. Once this is dry, lightly glaze over these areas using Quinacridone Gold mixed with a little New Gamboge. Permanent Brown will give you a darker, rich brown to use in those areas that need to be deeper in value. Once this is dry, a soft glaze of Quinacridone Burnt Orange in some areas will give life and the appearance of a glow.

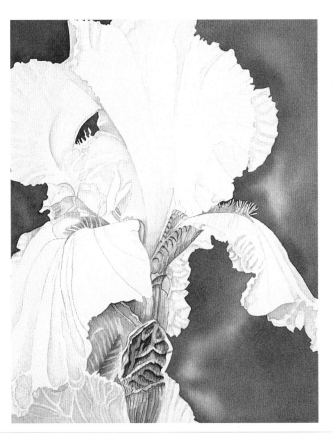

4 Deepen Values

Apply another wash over each background section with a mixture of Sap Green and Indanthrone Blue, making sure to save your light edges. Continue with the same colors you've mixed for the flower, deepening the values and maintaining soft edges. Do the same with the stem area, creating stronger values so there is good contrast. You can glaze some Quinacridone Sienna on the brown areas to give them more life.

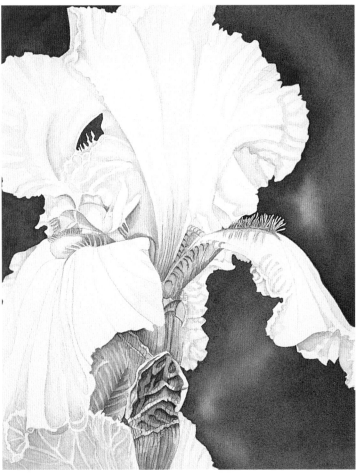

5 Punch Up the Contrast

Glaze everything again, including the background, with the same colors to strengthen the values. Stand back to check that everything reads easily, and decide if you need to define or strengthen any areas. Once it is completely dry, give the background another wash if you choose. The darker the background is, the greater the contrast, pushing the white of the flower forward more.

perfect the push and pull of colored petals

Painting flowers means painting petals. If they all look alike, the flower is not only going to look boring, it also will look flat. To make flowers like these roses appear more lifelike, you need to push some petals back and bring some forward using contrast, shadows or even pure color against slightly grayed color. These create a dynamic of push and pull, appearing to pop some petals forward to the viewer and others back into the background to give roundness to your flower. (See the full painting, *Aglow*, on page 23.)

Materials

Palette
Indanthrone Blue
New Gamboge
Quinacridone Gold
Quinacridone Rose
Sap Green
Transparent Brown Oxide

Brushes
Round: nos. 4, 8, 24

Paper
300-lb. (640gsm) cold-pressed

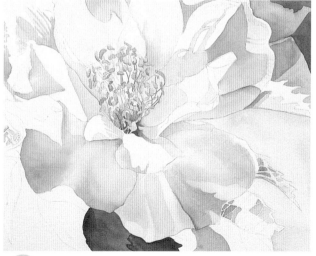

1 Begin Lightly

Over a light drawing, lay in some light local color to begin finding your shapes. Here some background has been added so the petal shapes are more obvious, but the background is a process best left toward the end of the painting so no darks drift into your light petal areas. Prime and glaze these first shapes with New Gamboge. When this layer is dry, prime and glaze with Quinacridone Rose. Keep the colors separated and the whites preserved by lifting back the color with a thirsty brush if needed.

2 Build Light Glazes

Continue to apply clean, light glazes of either New Gamboge or Quinacridone Rose, finding new shapes and defining more clearly the stamens in the center of the bloom. Use Transparent Brown Oxide to begin deepening the center of the throat of the rose and defining each stamen head.

3 Vary Your Shadow Colors

The shadows on the upper-right petal range from cool green to warm pinks. A variety of color is more interesting than one long passage of a single color. The green shadows help maintain a limited palette and unify this piece with the background. Unusual colors will read correctly to the viewer as long as they are the right values.

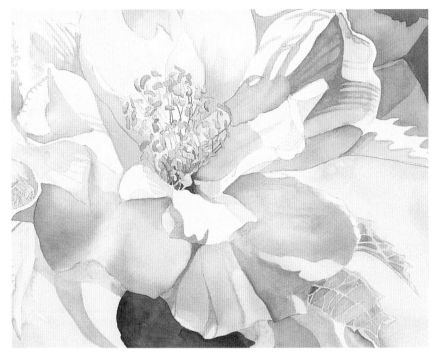

4 Deepen Values in Select Areas

Glaze the petals again with a coat of New Gamboge. When this is dry, add a glaze of Quinacridone Rose in the areas where you need deeper values. Placing darker values behind the front petals will push the center forward, and the back petals will begin to recede into the background. As you layer more soft glazes of yellow, the petals will begin to glow. Use Quinacridone Rose plus a bit of Indanthrone Blue to make a darker pink for shadows and veins in the petals. I've added a darker background to better show you how the contrast is working.

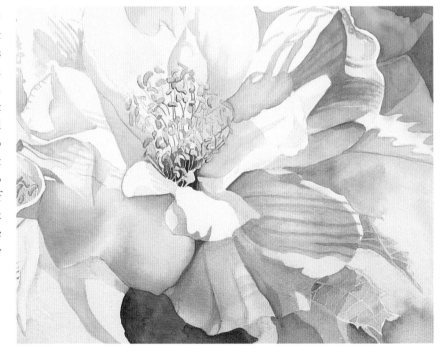

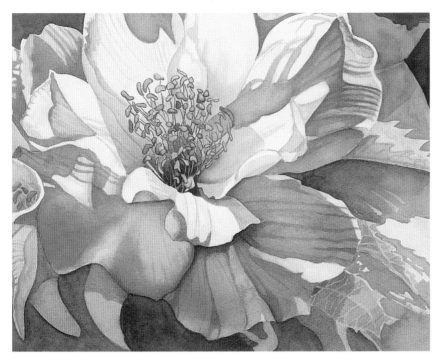

5 Push and Pull the Petals

Glaze washes of New Gamboge mixed with Quinacridone Gold onto the center area and the lower petals to help push them back. Add layers of Sap Green at the edges of the front petal, deepening the values to anchor the base of the petal back into the flower. Keep your purest white on the front petal to make that area really come toward the viewer.

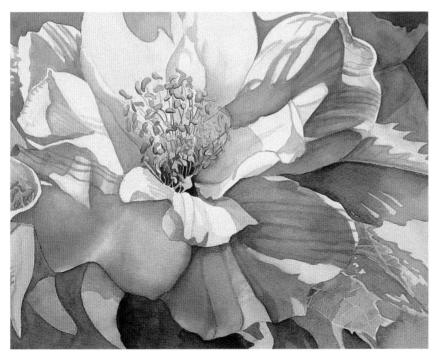

6 Heighten the Contrast

Under the front petal, deepen the shadows again with a mixture of Quinacridone Rose and Indanthrone Blue. This sets up a high-contrast area of light against dark and pure color against a grayed-down color, which helps to make the flower center pop.

make leaves that live up to the flower

The vivid red of these hollyhocks undoubtedly catches the eye, but capturing a likeness of the leaves is important to make this plant look real. Hollyhocks are noted for their unique leaves, so accenting and exaggerating this feature will make the painting more interesting.

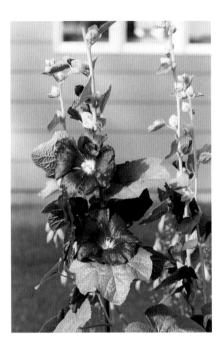

Reference photo

Materials

Palette
Anthraquinoid Red
Aureolin (Cobalt Yellow)
Indanthrone Blue
Naphthamide Maroon
Naphthol Red (M.Graham & Co.)
New Gamboge
Permanent Violet
Perylene Red
Perylene Scarlet
Phthalo Blue (Green Shade)
Pyrrol Crimson
Quinacridone Fuchsia
Quinacridone Gold
Quinacridone Rose
Quinacridone Sienna
Sap Green
Brushes
Round: nos. 8, 24, 36
Round scrubber
Paper
300-lb. (640gsm) cold-pressed
Other
Jo Sonja's Acrylic Gouache: Phthalo Blue, Warm White (optional)

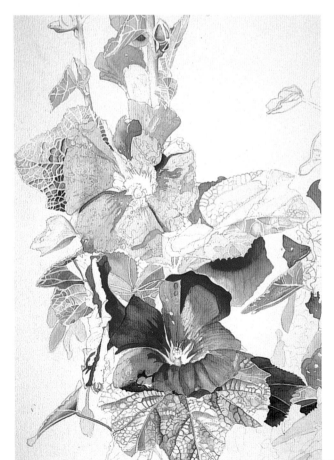

1 Find Shapes With Light Washes

Make your drawing as accurately as possible, making sure you know where the veins in the leaves are going to be and including any detail that will help describe these leaves as thick and textured. Begin with light washes of New Gamboge and Sap Green on the leaves to find the general shapes. Carefully work each section so you don't lose the vein pattern. Lay light washes of Perylene Red, Quinacridone Fuchsia and Anthraquinoid Red into areas of the flowers to find their shapes. Drawing a few shapes within the flowers makes it easier to place these initial washes because you know where you're saving the whites.

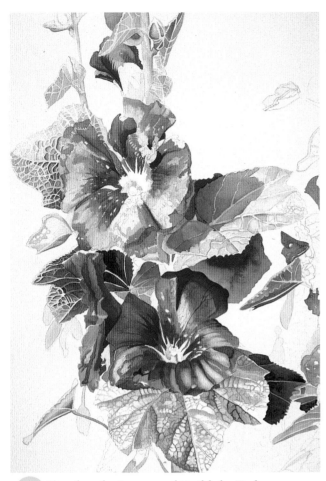

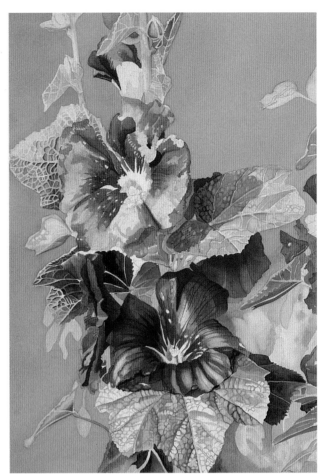

2 Develop the Leaves and Build the Reds

Develop all the green areas simultaneously, not only to keep their coloring and texture pattern similar but to help you judge more easily how dark your darkest leaves need to be. Erase the vein lines and paint the veins with light New Gamboge. Remember that veins seem more pronounced where light passes through them. Preserve the veins in the upper-left leaf so they stand out. Exaggerating the texture in the lowest leaf will add more interest and draw the eye up to the flower. Using a very light wash of Phthalo Blue and Sap Green, paint a cast shadow on the large upper-right leaf, carefully avoiding the veins.

Using only one red for the flowers could easily result in a flat-looking blossom, so work in very light layers with a variety of hues, glazing slowly and letting each layer dry before adding another. Let the natural values of the reds be your guide. For a dark value, for instance, use a darker red such as Perylene Scarlet or Pyrrol Crimson. At this point there are perhaps five light washes of different reds. Use more Perylene Red toward the flower centers; it is a brighter, truer red that will make that area glow. The darker red areas in shadow have Naphthamide Maroon, and some have Permanent Violet, to deepen the shadows. Leave white in areas of the flowers to give the feeling of light on the petals.

3 Choose a Bright Background

The background can be added now that most of the flower edges are done. A bright blue will create drama and really make the leaves pop forward. At first I applied Phthalo Blue toned down with a bit of Indanthrone Blue. When the first watercolor wash revealed a flaw in the paper and resulted in unsightly streaks, I turned to Jo Sonja's Phthalo Blue acrylic gouache applied in numerous light washes to solve the problem. A second watercolor wash would only have rendered the flaws more obvious.

After applying another wash to the shadow on the right leaf, gently lift some areas with a round scrubber. Gentle scrubbing will remove the green and expose the yellow underpainting.

Add some very light abstract shapes to the background to represent other foliage and flowers. Lay in some soft pinks and then do negative painting around them, softening edges with water. With a mix of Quinacridone Gold and Aureolin, add a soft glaze on the sections of leaves reaching into the sky on the left to show sunshine coming through them.

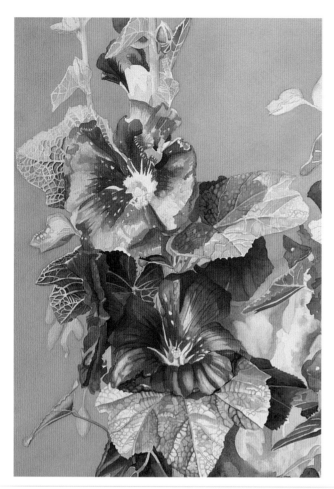

4 Continue the Reds and Work on Surrounding Areas

Continue to do light washes of different reds to deepen the flowers. Glaze with Quinacridone Rose where the red seems dull to enliven it. Add detail to the centers of each flower with New Gamboge and Quinacridone Gold. The background on the right has slowly been developing with abstract shapes. Now, with another wash, darken areas and do more negative painting. You will see shapes you can paint around and develop more leaves or flowers. The bottom area needs to be darker to give the painting weight, so develop some darker leaf forms in that area.

You no longer need the reference photo because you have the map strongly established. Work around the entire painting so you develop it as a whole. This way you can more easily see where you want to push edges back, playing dark against light to pop edges forward.

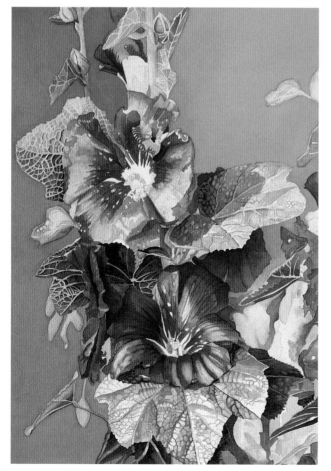

5 Perfect the Push and Pull

Push areas deeper into shadow and bring forward edges that touch those shadows. These adjustments are critical to make the viewer's eye move through the painting.

Darken the background to the left again so the sky gradually gets lighter as it goes to the right, creating an atmospheric feel. Punch up some of the reds to bring them forward. The flower on the middle left needs a bright edge of red; use either straight Perylene Red or Naphthol Red, which will move those petals forward. I like Naphthol Red for its brilliance, but work with this semiopaque pigment only near the end of the painting process. It will deaden an area if you build it up, but a single glaze can enliven your other reds.

Add more light to the leaves against the sky on the left side by applying a wash of Quinacridone Gold plus Aureolin to the edge that meets the flowers.

6 Develop Depth and Shadow

Deepen the top flowers with more Perylene Red and some Naphthamide Maroon. Deepen the cast shadow on the upper-right leaf without losing the veins. This will set the back of the leaf under the flower and give more depth. Lift a few more areas in the shadows if you have lost them. Apply a wash of Phthalo Blue for a nice shadowed edge where the bottom flower lies on the leaf. Paint a few washes of Phthalo Blue and Sap Green over some of the leaves to suggest blue sky reflected on the leaves.

The small pink buds and the flowers on the right edge are too distracting, so darken them to push them further into the background. Deepen the background in the lower right so the large leaf comes forward more, and deepen the reds on this side. You don't want any of this area to distract the eye. Another glaze down the left side of the sky makes the leaves more prominent.

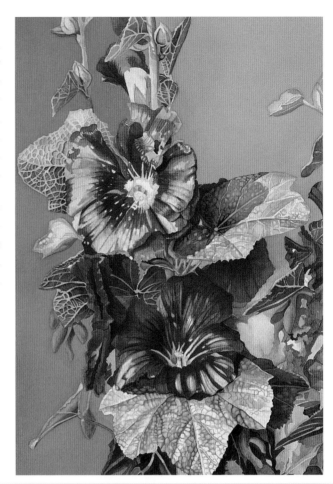

7 Examine the Edges and Suit the Textures to Your Taste

Carefully look at all the edges to make sure they are as clean as you can make them where it counts. Any areas touching the sky need to have solid edges. Use a very small mat to review every square inch of the painting to see if it looks finished. Notice that the leafwork is not hard edged; colors overlap with each glaze to keep them soft. Some texture is definite, but in other areas only suggested. You may not like as much texture, so change things to suit your style. I love and happen to be known for exaggerating the veins, "lumps" and general characteristics of leaves. Find what you love and make that your signature.

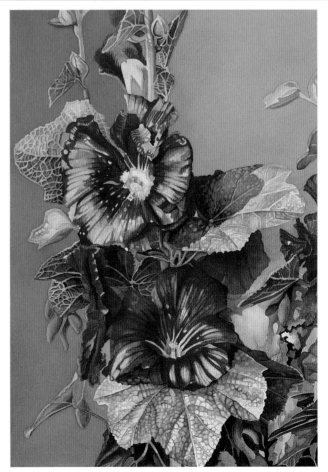

Highlight Help

I was so pleased with how the acrylic gouache worked for the background that I tried the only white acrylic gouache I owned (Jo Sonja's Warm White) for adding highlights. Since this was now an experimental piece, not a pure watercolor, I had nothing to lose! I love the effect but would use Golden's Titanium White next time, as Warm White has a gray cast to it.

8 Add a Sunny Touch

Apply final glazes of Quinacridone Gold mixed with a little Aureolin over parts of the leaves to give them a wash of sunshine. Add glazes of Quinacridone Rose and Quinacridone Sienna to any red areas that look dull and need more punch. Check all edges once more to make sure you are satisfied with them.

Rejoice
Watercolor and acrylic gouache on cold-pressed paper
21" x 15" (53cm x 38cm)

try an unusual view for an unforgettable story

I love visiting the poultry barns at the local county fair. This painting is of my neighbor, Beth, who raises some of the most beautiful chickens. I was unaware that, for judging, the chickens are carried into the ring backwards. I guess this way they don't know what is going on and remain calm.

I was immediately drawn to this composition and asked Beth to pose for me. Her dark hair formed stunning shadows on her crisp white shirt, and the ribbons in her back pocket helped tell this story. By seeing them, you know this is a competition, and the rooster tells you what type. I needed to keep the focus there, so I immediately decided that Beth's face would not be in the painting, as it would really compete for attention.

Materials

Palette
Carbazole Violet
Indanthrone Blue
Indigo
Manganese Blue Hue
New Gamboge
Permanent Brown
Perylene Red
Perylene Scarlet
Phthalo Blue (Green Shade)
Pyrrol Crimson
Quinacridone Burnt Orange
Quinacridone Burnt Scarlet
Quinacridone Gold
Quinacridone Rose
Quinacridone Sienna
Sap Green
Transparent Brown Oxide
Brushes
Round: nos. 6, 8, 10, 24
Round scrubber
Paper
300-lb. (640gsm) cold-pressed

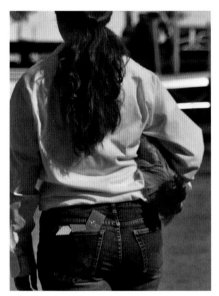

Reference photo

Lay In the Major Shapes

After drawing, lay in the first washes, starting with the jeans (Indanthrone Blue brightened with a little Phthalo Blue). As you paint, be aware of the fading in the seams and where the yellow stitching will go. Leave white for these areas so you can have clean highlights. Once this is dry, add a second wash on the far left side and right side to begin establishing where some darks will be.

Give the hair and rooster a wash of New Gamboge plus Quinacridone Sienna and let it dry. Wash Permanent Brown into some of the areas of the hair that are darker to establish some movement and shapes. Use a reddish orange wash (Perylene Red with a little New Gamboge) for the rooster comb and wattle. Do this lightly, as red is staining and you want to build up this area gradually. Place a little New Gamboge in your stitching lines to mark them.

107

Start the Shirt

Apply a wash of your blue mixture (Indanthrone Blue plus a little Phthalo Blue) on the left pocket, making the shadow side a little darker. From now on, to make the left side darker, use straight Indanthrone Blue washes. Make a soft lavender-gray from Indanthrone Blue, Perylene Red and a little New Gamboge for the shadows on the shirt. This same mixture will be used for the cage area and the background. Work lightly and soften the edges on these shadows where the fabric folds.

Mix a dark brown (Transparent Brown Oxide plus a little Carbazole Violet) to paint around light strands of hair to define them and for some of the darker shapes in the hair. Draw as much hair detail as you want so you know where you want lights, midtones and darks to be. Wash Quinacridone Sienna onto the rooster around some of the feathers. Using the lavender-gray mixture, brush on the shadows the hair creates on the shirt. Work loosely, leave whites and paint lightly since this is just the first wash.

Define the Hair and Begin the Background

Add more hair shapes, applying Quinacridone Burnt Orange, Quinacridone Sienna and Transparent Brown Oxide onto different strands. For a darker, rusty brown, mix Sap Green with Perylene Red. Darken the jeans with washes of Indanthrone Blue; show the folds in the legs.

Since the rooster is the focal point, develop it now and base other values on it. Deepen areas with the same colors used in the hair, but make the rooster generally lighter so it attracts more attention. Paint its eye black (Indigo plus Perylene Red). Glaze the comb and wattle with Perylene Red, Pyrrol Crimson, Quinacridone Gold and Perylene Scarlet. Once this dries, add a light glaze of Quinacridone Burnt Orange in places for more glow. Deepen the shadowed areas in the reds of the chicken with Quinacridone Burnt Scarlet.

Paint the cage area and the chickens inside using your lavender-gray and black mixtures. Lift areas to look like straw. When this is dry, wash Quinacridone Burnt Orange over the area. Glaze the wires with Manganese Blue Hue and the lavender-gray mixture. Don't leave any eye-catching true white on the background chickens.

Deepen any of the shirt's shadows that need to be pushed back, and warm up most of them with a light Quinacridone Rose glaze. This scene takes place in July, so we should feel the heat even in the shadows.

Tie Things Together

Deepen all the shadows and areas that are too light with more washes. Glaze sections of the hair with Quinacridone Sienna, Quinacridone Burnt Orange and Quinacridone Gold so you have many colors and values for depth. This will move some of the darker browns, causing them to lighten; strengthen them again in places with Transparent Brown Oxide, and also deepen areas by adding Carbazole Violet to the brown.

Apply the same colors as a glaze over more of the straw you lift out with your scrubber brush. Continue to use the same lavender-gray in the background as used on the shirt, for unity and to make the more colorful areas jump forward. With a large round, prime one side of the background and wash in the lavender-gray, making it lighter toward the top. Repeat on the other side. Let this dry, then repeat to darken it. The setting is a huge chicken barn, kept pretty dark so that it will stay cool; therefore, not much detail can be seen. You'll only need to suggest shapes in the background, such as the flags.

Determine Where to Crop and Work on the Details

Just above the collar is a nice place to crop. It leaves two attractive negative shapes on either side, and the wider part of the ponytail creates a nice top border. What now becomes apparent is the strong triangular composition of the ponytail, ribbons and rooster.

Complete the ribbons in the pocket and paint the lettering carefully, as this is close to the viewer and what is said on the one that is readable will be of interest. Knock back the white label on the cage so it blends into the background more instead of being a distraction. The ribbon in her hand needs to be different; giving it a few washes of Quinacridone Rose will balance it better with the red comb and wattle on the rooster.

Each glaze of color to the hair will move some of the Transparent Brown Oxide because it is such a transparent color, so you will have to regularly redefine those darks. Define more of the strands with your dark brown mixture (Transparent Brown Oxide plus Carbazole Violet) after you've finished adding more glazes of Quinacridone Sienna and Quinacridone Gold to the tops of hair masses, and Quinacridone Burnt Orange to the shadows of the hair. Make a few of the top hair sections glow with final glazes of Quinacridone Gold and Quinacridone Rose.

6 Fine-Tune the Shadows

Add light glazes of the Quinacridone colors used for the hair to the grays of the shirt shadow under the hair so it appears that light is bouncing and reflecting color there. This will liven up that shadow and make it more interesting. Notice that the shadows on the left side of the hair are several different values of gray painted to look like hair rather than a solid shadow. This gives greater interest to that area and feels more realistic.

Check your edges and make sure all pencil lines have been erased. Try using a small mat to isolate areas so you can see the paint edges to make sure you do not have messy lines. It is hard to see this when you look at the entire painting, but the minute you frame it, these errors will pop out.

Spend some time looking at the painting to decide if you need more darks in the hair, chicken or jeans, and follow your gut instinct. Do not be afraid to add more glazes of color if an area doesn't seem to be working. If you're not sure you are done, set your painting up some place where you pass by often and study it. In a few days, it will tell you if you need to do any more work.

Beltrami County Fair
Watercolor on cold-pressed paper
25" x 21" (64cm x 53cm)

I am not a photorealist, but I like to see how closely I can represent something using simple brushstrokes. The unusual lines of this crystal bowl really attracted me. I made the drawing as accurate and believable as I could, but I also allowed room for artistic interpretation. Much of the cantaloupe's rind texture is just suggested rather than reproduced exactly, and glass shapes were simplified in places.

I photographed this setup outside in bright sunlight. Grass provided a background color, and the bright sky reflecting in the bowl offered a nice variety of blues to complement the orange melon. When the photos came back, I saw the wonderful light-green halo that occurred, which inspired a more interesting background than just a solid dark.

Materials

Palette
Indanthrone Blue
New Gamboge
Perylene Red
Phthalo Blue (Green Shade)
Phthalo Turquoise
Quinacridone Burnt Orange
Quinacridone Gold
Quinacridone Rose
Quinacridone Sienna
Sap Green
Transparent Brown Oxide
Undersea Green
Brushes
Round: nos. 8, 10, 24
Flat wash or hake: 2-inch (51mm)
Paper
300-lb. (640gsm) cold-pressed
Other
Masquepen masking fluid

Reference photo

1 Draw Accurately and Use Color to Place Shapes
An accurate drawing is critical with crystal because there are so many shapes and saved whites to keep track of. With a Masquepen, draw squiggly lines on the edible area of the center cantaloupe. Once this is dry, prime the area with water and lay in a light-orange wash (Perylene Red plus New Gamboge). After this dries, prime again and repeat the wash to strengthen the color. When the second wash is dry, remove the masking to reveal the white lines that will represent light hitting the peaks of the fruit flesh, creating texture without being distracting. Use the same light-orange mixture on the other melon pieces and begin defining their centers. Glaze areas with Quinacridone Burnt Orange and Quinacridone Rose to give depth and define some shapes. Apply a wash of Transparent Brown Oxide in the darkest areas. By working in sheer glazes that you let dry fully, you can make the centers glow.

Begin adding color to a few of the shapes that are easy to spot in the bowl to begin establishing the form. Use a purplish gray mixed from Indanthrone Blue plus Perylene Red. This mixture will appear throughout the crystal.

2 Define the Melon Rind and Continue the Bowl

Define the rind of the fruit with a light tan color (New Gamboge plus Transparent Brown Oxide). Paint the shadow across the top of the lower-right melon with a grayish green (Undersea Green plus Perylene Red).

Develop more of the bowl by painting each abstract shape. Using the purplish gray and light-orange mixtures, Transparent Brown Oxide, Indanthrone Blue and Phthalo Blue, paint the shapes you have drawn for the glass. Refer to an enlarged copy of the photo to see the values and follow your drawing. Mix Sap Green and Indanthrone Blue for a nice dark for the glass to the back, which is reflecting the dark background to come.

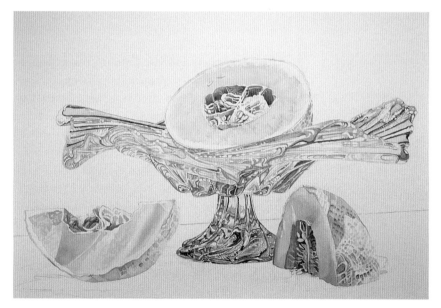

3 Develop the Bowl's Shape and the Melons' Interiors

Continue painting more shapes to define the shape of the bowl. Even though you are seeing and painting the bowl as groupings of abstract shapes, always keep in mind that these shapes must combine to read as swirling crystal in a specific pattern. Be sure to leave areas of white as you paint. Also remember that some of these random shapes are actually reflections of the melon flesh and rind. This can get confusing, so stand back often to view your progress to make sure your lines are reading accurately. If they do not convey the shape of the bowl, spend some time redrawing areas so your shapes read true.

Further define the interiors of the melons by glazing with the same colors and adding a wash of Quinacridone Gold to help areas begin to glow more. Add Quinacridone Sienna for some sparkle as well.

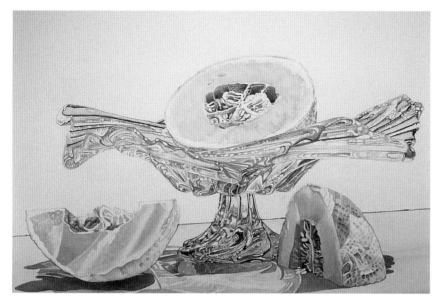

Start the Surroundings

4 Carefully prime then wash Transparent Brown Oxide into areas of the table to begin showing the shadows and the tabletop. A careful drawing in this area makes this a simple step. Soften the edges so the shadows don't have hard lines, and add another brown glaze to deepen areas.

It is critical to save whites not only in the glass, but even in the cast shadows from the glass. When the painting is complete, these whites will depict intense light shining onto the table, bowl and fruit. I used Masquepen on the edges of the melons, for the table edge and in the cast shadows. The masking was not essential; I wanted to test the product and these were good places to try it, as these particular edges were not critical to the painting's success. It did work well, so I'll use masking again when I need to preserve fine lines and edges with fairly good accuracy.

Begin the Background

5 Run the masking along all edges that meet the background to protect them and make the background washes easier to apply. This background is large, and there are many shapes to paint around. It will be critical to move as fast as possible, so use a 2-inch (51mm) flat wash or hake brush or the largest size you are comfortable with to cover this area quickly. Prime the entire background several times so it is evenly wet, with no puddles. Apply light Sap Green on the area shown over the bowl and under the left rim. This will be our halo as shown in the reference photo. All edges will need to be softened and evened out with a thirsty (damp) brush before the paint dries.

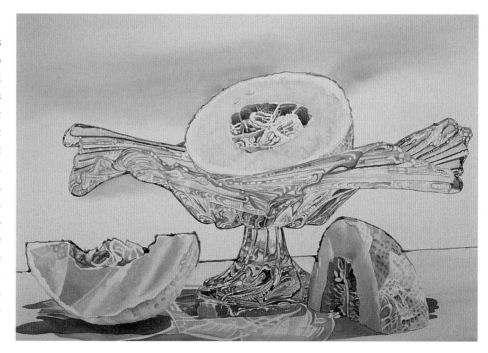

6 Continue the Background

When this is completely dry, prime the entire background again and apply a wash of Sap Green mixed with Indanthrone Blue with your large flat wash or hake brush. Working quickly, move the paint evenly into all the small areas around the fruit and bowl with a no. 8 round, up to the masked edges. Avoid placing any paint in the halo area; that area should have only the clear prime on it. Soften the darker wash around the edges of the halo area so that as it dries, it will have a smooth transition. When everything is completely dry, apply a second wash just as you did this one, allowing it to become darker under the bowl and along the outer edges.

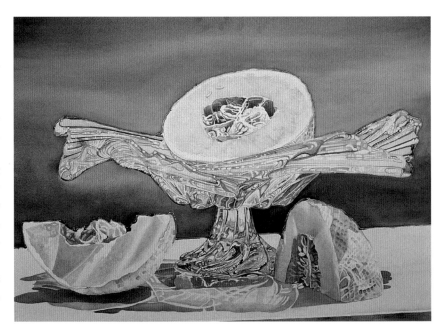

7 Heighten the Contrasts

Stack several more washes on the background to make it dark so the halo area will glow. With washes of Quinacridone Burnt Orange, Quinacridone Sienna and Quinacridone Gold, begin detailing the melons to make sure the seeded areas give good contrast and glow. Wash the shadows on the table with these colors also so it will have a glow. Place light glazes of Quinacridone Gold on the melon rinds where the sun hits them or where color needs to glow because light is reflecting up onto the rind. Define the seeds on the surface of the center melon with Transparent Brown Oxide.

Remove the masking once everything is dry and add glazes of Sap Green, Phthalo Turquoise and Transparent Brown Oxide to enrich all the glass areas. Glaze Phthalo Turquoise or Sap Green over some of the grays to give them more life.

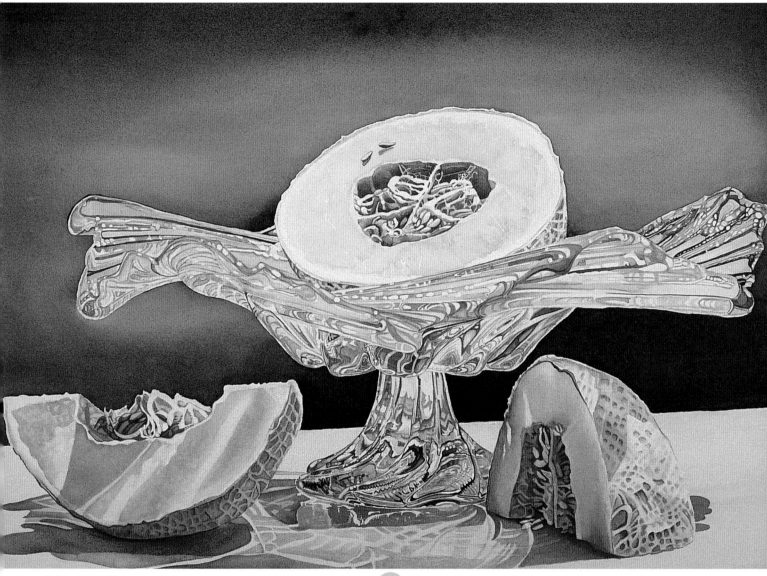

A Slice of Summer
Watercolor on cold-pressed paper
20" x 29" (51cm x 74cm)

8 Define Values and Clean Up Edges

Check all the glass to make sure it reads correctly, and clean up any messy edges. Give some extra definition to the melon rinds. Notice how important it is to have different values in the three melons. Making the center melon lightest tells us it is in the brightest light. Keeping the melon on the right dark but the rind edge white shows the shadow the bowl is casting over it. Variety in the shadows, such as the striped shadow on the left melon, makes each melon interesting to look at. Variety keeps the viewer involved in the painting for a longer period of time and causes one to return to see if something more can be learned from it.

Looking Back

If I could do one thing differently, it would be to add several more glazes to this background to make it darker and more dramatic. Here's why I didn't: After applying my first wash I noticed fingerprints on the top edge of the paper. The next wash made them darker and more visible, as they were absorbing more paint. Had I gone any darker, the fingerprints would have become even more noticeable, so I chose to stop. The lesson here is to watch how you handle your paper before you even lay paint to it. (See "Drawing Tips" on page 29.) Chances are you will not see the damage caused by incorrect handling until color has been applied and has dried.

shine a spotlight on the star of a busy scene

This scene has a number of different textures and patterns going on that are interesting to the eye but might quickly overwhelm the viewer. Establishing the center of interest—a high-contrast area among the three pears, where a strong beam of light shines—at the very beginning is critical to this painting's success.

Materials

Palette
Carbazole Violet
French Ochre
Indanthrone Blue
New Gamboge
Phthalo Turquoise
Quinacridone Gold
Quinacridone Rose
Sap Green
Transparent Brown Oxide
Brushes
Round: nos. 8, 24
Scrubber or old toothbrush
Paper
300-lb. (640gsm) cold-pressed
Other
Masquepen masking fluid
Coarse salt
Old credit card or plastic scraper

Reference photo

1 Establish Pear Shapes

When you make your drawing, focus mainly on the pears' surroundings and not so much on the pears themselves. Then pencil in only the overall shape of each fruit. Place a light wash of New Gamboge over areas of the three pears where you want a glow to occur, leaving some areas of white. Once this is dry, add soft washes of Sap Green, and, on the lower pear, some Quinacridone Rose. Sprinkle some salt over the Sap Green on the left pear to develop a texture that is different from the hand-painted texture in the other pears. Let this dry completely, then scrape off the salt.

2 Build Texture

Develop each pear differently so each is interesting on its own. Since this area will be the center of interest, set the stage for plenty of texture to attract the eye. Apply Sap Green, New Gamboge and Phthalo Turquoise, working slowly and lightly for a soft, natural look. By creating texture with your brush, you can control how soft or hard you want the edges to be. I've kept mine quite soft for the most part. A mottled effect can be created by painting around shapes, creating areas of light surrounded by darker colors. A random pattern is best.

3 Add Darker Values and Soften the Textures

Glaze over each pear with washes of New Gamboge or Sap Green to set the texture into shadow or under layers of different colors. The texture should not be pronounced but should maintain an interesting appearance. You don't want the texture to upstage the value contrast, which will be the main attraction to this area.

Continue to glaze the pears by floating in color on the primed surface to soften the texture and place the shadows. Use Sap Green, New Gamboge, Quinacridone Gold, Phthalo Turquoise, Indanthrone Blue and Quinacridone Rose. Once you are satisfied with the appearance of the pears, stop; avoid making them too dark until the rest of the painting is completed so you can gauge values more accurately.

4 Begin the Plate

This plate is a very heavy, decorative metal plate from the late 1940s. Its color is not a shiny gold but rather a darker matte color, and the plate is not flat but has a deeper center. Use a mixture of French Ochre, Transparent Brown Oxide and Quinacridone Gold. It is very important to keep it a light wash where the sunlight is strongest. Making the inner and outer edges of the plate's rim darker will begin to convey the idea that it is curved rather than flat. Place a second coat of the gold mixture in the shadow area so it begins to look darker than the sunlit areas.

Place one coat of Transparent Brown Oxide in some of the holes in the plate edge so that you have a darker value to compare to. This helps the lighter areas appear even lighter. Save the white of the paper for tiny glints of light around these holes. (A Masquepen is useful for this.)

5 Make the Plate Glow

Save the design in the center of the plate with masking, then paint it with Phthalo Turquoise. Apply a second wash in the shadows of the pears with a little Quinacridone Gold added to the edges to show sunlight bouncing in those darker areas. Add another light wash of Quinacridone Gold and Transparent Brown Oxide to the gold plate edge that is in shadow to set it back even further. Add more of the dark holes in the plate pattern; the plate will begin to glow now that it has a full range of values. Removing some of the masking reveals the glints of light. As you continue, give most of these tiny saved areas a very light wash of color. They'll still be effective without being distracting.

6 Tackle the Tablecloth

Fill in the pattern in the plate's center with Quinacridone Gold and New Gamboge. The tablecloth pattern is a relatively simple one, so I chose to do it mostly freehand. I placed a few guidelines, but by thinking it through in my head, I knew pretty much where the design should be placed. When describing patterns such as this, it's important to stop and study just one small part to see what is actually happening. Understanding the pattern will make painting it much easier.

Develop some folds in the cloth to make it more interesting than just a flat cloth. The shadows under the pears need to be darkened, so use Phthalo Turquoise with a little Indanthrone Blue for a darker mixture to flood into the shadows.

7 Give the Tablecloth Some Dimension

Fill in the top corners of the painting with several washes of Transparent Brown Oxide darkened with Carbazole Violet. Also use this mixture to darken areas of the tablecloth and for shadows on the tablecloth. Because the tablecloth is done in a transparent color, you can lift the highlights easily with an old toothbrush or scrubber. Once those highlights are dry, lay in a soft wash of Quinacridone Gold to give them a touch of sunshine. Deepen the shadows under the plate again.

8 Strengthen the Shadows

I thought the painting needed more depth at the bottom to make it feel as though very strong sunlight was hitting the pears. I decided to strengthen the tablecloth shadows below the plate with another wash of Transparent Brown Oxide plus Carbazole Violet. When this area became darker, the rest of the dark shadows had to be strengthened to correspond. Darkening the part of the tablecloth in the upper-right corner as well made it recede further and added more variety to the different values to brown. I also deepened the brown squares in the pattern in a number of areas.

Now the pears do not need to be darkened as I had previously thought. By developing the rest of the painting before trying to darken them any further, I could compare values much more easily. Working slowly and gradually can save you from going too dark too soon.

Celebration of Light
Watercolor on cold-pressed paper
21" x 22" (53cm x 56cm)

play opposites off one another

Complements placed side by side tend to make each other seem brighter and more colorful. In this example, the old turquoise wagon really showcases the orange pumpkins. The interesting textures of the rust and the cement play off the smoothness of the pumpkins.

This painting has a much larger palette than usual because I wanted to try some of the colors that I rarely get a chance to use. This painting endured a lot of trial and error, but now I know what those colors can do. Remember, not every painting has to be for a juried show! Sometimes you've got to play to grow.

Materials

Palette
Burnt Sienna
Carbazole Violet
Cobalt Teal Blue
Goethite
Hematite
Indanthrone Blue
Lunar Earth
Moonglow
New Gamboge
Perylene Red
Phthalo Green (Blue Shade)
Pyrrol Orange
Quinacridone Burnt Orange
Quinacridone Burnt Scarlet
Quinacridone Gold
Quinacridone Rose
Quinacridone Sienna
Sap Green
Transparent Brown Oxide
Undersea Green
Vivianite (Blue Ochre)
Brushes
Round: nos. 6, 8, 24 (largest brush for cement only)
Scrubber
Paper
300-lb. (640gsm) cold-pressed
Other
Coarse salt
Old credit card or plastic scraper

Reference photo

Mind Perspective as You Draw

If perspective is complicated for you, you can use a grid as I did for the wheel to make sure your drawing is accurate. (See page 29 to learn more about the grid method.) The wheels in the reference photo are slightly bent, so I straightened them somewhat to avoid having the viewer think that I did not know how to draw them properly. So, decide how bent you think they need to be to tell the story without becoming a distraction.

If you need help with the perspective on all of your drawing, then use a grid the entire image. Notice that we are working with a triangular composition.

Block In Your Main Colors

Wash Cobalt Teal Blue on the wagon, keeping the ridges that are catching the light a lighter value or white as necessary. Add Hematite to Phthalo Green to paint the shadows on the right side of the wagon and the shadows cast on the inside right wheel. Hematite is a mineral color and will granulate, adding texture to these shadowed areas. Use Quinacridone Sienna and New Gamboge in light washes on the pumpkins, being careful to save the whites. Make a light wash of Transparent Brown Oxide to begin modeling the handle and metal under the wagon. Where the metal is in shadow under the wagon, add some Indanthrone Blue to your brown mixture to make it darker.

Create the Cement

Painting the sidewalk a warm color will accent the cool wagon. Make enough of a thin Moonglow mix to cover the entire area. Use a scrap of paper to test the color with salt, because salt will lighten the value as it dries and absorbs the paint. Use the largest round brush you can for this; the faster you go, the more success you'll have. Start in the upper left or right part of the cement and work around to the other side, moving around the leaves and rocks you've sketched. As you go, quickly sprinkle coarse salt over the wet mixture. Do not put your brush back in an area after the salt is applied. Continue until the entire sidewalk area is covered and salted. Where there is more pigment, there will

be greater separation, as you can see in the foreground and upper-left area. Let the paper lie flat until completely dry.

Once it's dry, scrape off the salt. Lay in a light wash of Moonglow for the shadow under the wagon. Define the pumpkins more with another glaze of Quinacridone Sienna, which will begin to make them look more orange. Grading that color and leaving some white will start creating their roundness. For the pumpkin on the ground, paint a very light shadow of Moonglow at the base and up the side on the right. With a dark mixture of Undersea Green, start to paint the background foliage using negative shapes. Apply a wash of Hematite plus Vivianite to some of the rocks.

4 Use Muted Colors in the Background

Mix Moonglow and Goethite to create the foundation color on the building. (You can use a little Transparent Brown Oxide to gray down the Moonglow if you do not have Goethite.) Add more detail to the foliage with Sap Green, Quinacridone Gold and New Gamboge. Add some rust to the bent part of the wagon handle using Burnt Sienna, Quinacridone Sienna, Quinacridone Burnt Orange and Transparent Brown Oxide until it looks rough. Define the ridges in the pumpkins more with Quinacridone Burnt Scarlet and Quinacridone Burnt Orange. The space between the pumpkin on the ground and the wheel needs a wash of Moonglow, like the rest of the shadow under the wagon. Fill in the lighter rocks with Lunar Earth and Goethite.

5 Make Your Orange Believable

Orange can become very opaque and lose its glow, so continue to use transparent colors until you're closer to finishing. Then, where you want an intense orange, use a mixture of Pyrrol Orange and New Gamboge in a light wash. Continue to build up the shapes of your pumpkins, using Quinacridone Rose to give them roundness on the edges. This will help them glow and appear to reflect the light. Add more glazes of the pumpkin colors you have been using. Using Sap Green, Undersea Green and New Gamboge, begin to define the tops of the pumpkins.

Make the burgundy color under the leaves at the bottom by mixing Sap Green and Quinacridone Rose. Paint the lattice with Transparent Brown Oxide, Quinacridone Gold and Burnt Sienna. Make another wash of Moonglow on the shadow side of the pumpkin on the ground so it begins to blend into the shadow on the ground.

6 Build Up the Rust

Build up the rust on the handle and around the body of the wagon. There have to be many colors here to give it depth and make it feel rough. Mix Carbazole Violet with Transparent Brown Oxide to paint the deep brown areas. Use Quinacridone Burnt Orange as well, and apply glazes of Quinacridone Sienna to give it some luster. The rust is a combination of all the colors in the pumpkins, plus Carbazole Violet, unifying the two areas. With careful observation, you can visually separate out the colors in rust. This is what gives the depth needed to look real.

Add another glaze of Phthalo Green to those areas of the wagon in shadow. Give the pumpkins more glazes of Quinacridone Scarlet, Quinacridone Burnt Orange and Quinacridone Rose to make an even richer orange.

Continue to work on the foliage by using a variety of greens. Mix Indanthrone Blue with Sap Green to get some nice darks, and for a brighter green, mix Phthalo Blue with Sap Green. You will use some Sap Green alone as well to create a number of different values of greens. Make sure your background stays understated by knocking back any colors that will fight for attention. I decided to eliminate the plants on the left side, so I painted the foundation in and lattice over that area to make it more in harmony with the rest of the background.

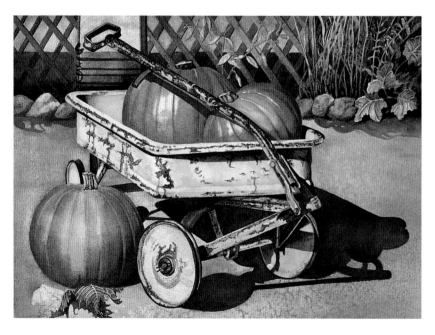

7 Finish the Rust and Deepen Other Values

Your rust at this point should be quite realistic. Make sure you have not lost the white reflection on the handle bar. If you have, you can lift some color out with a small scrubber. Also make sure your rust is darker on the edges of the handle so it recedes and makes the form appear round.

Deepen all the shadows on the pumpkins with another wash or two if they are not deep enough. Lastly, apply several glazes of Quinacridone Gold to the parts of the pumpkins where the light is hitting. The stems at the top of each pumpkin are Sap Green and Undersea Green. Once they are dry, give them a wash of New Gamboge.

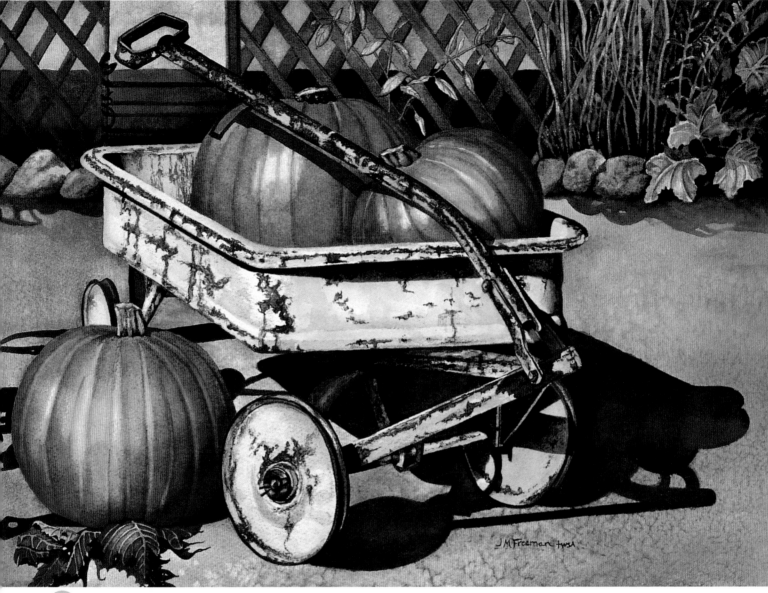

October's Harvest
Watercolor on cold-pressed paper
14" x 20" (36cm x 51cm)

8 Evaluate and Make Adjustments

Stand back and look at your painting. Where do you need darker darks? Maybe you need to scrub out some highlights that you have lost. Do you have a variety of values? Too few values will make the painting appear flat. Complete the leaves near the lower pumpkin with Perylene Red, Quinacridone Rose, New Gamboge and Quinacridone Sienna, keeping the middle leaf lighter on top to give it form. When this is dry, glaze Quinacridone Gold over the middle leaf and Quinacridone Sienna over the other leaves to enrich the color.

I noticed that there was nothing anchoring the lower pumpkin to the cement, so I added shadows coming from an unknown source. I tested the placement of these shadows by cutting shapes of dark paper from a magazine and taping them in different places to find the correct placement so I could apply that dark Moonglow with confidence. I wanted these to be interesting shapes, as I felt the entire left side was not interesting enough and needed to be broken up.

INDEX

Acrylics, 14, 67, 79
Backgrounds, 23–24, 65, 71–79
 blurred, 77
 color in, 74
 complex, 77
 dark, 77–79, 96–98
 detailed, 75
 fixing, 14, 75, 77
 glazing, 56
 haloed, 111, 113–114
 muted, 123–124
 planning, 72, 74–75
 simple, 78, 90–91
 smooth, 80–81
 textured, 32
 white, 69–71
Birdhouse, 11, 94–95
Birds, 27, 33, 77
Blues, 45, 93
Browns, 44, 47
Brushes, 12, 61–63, 85, 112
Cement, 43, 66, 121–122
Center of interest, 17, 22–23, 27, 32, 34, 40,
 76–77, 96
 placing, 22, 26, 30, 116–117
 value and, 14, 22, 42
Cherries, 34, 50
Color chart, 49–50, 52
Color schemes, 33, 38
Color temperature, 21, 35, 38, 48, 122
Color theory, 38
Colored pencil, 67–69
Colors, 37–53
 altering, 39, 58
 cast, 36–37
 complementary, 38, 42, 48–49, 121
 grayed, 40–42, 51, 101
 in light and shadow, 40–41
 lifting, 43, 57, 62–63
 limited, 48–49, 53
 local, 39, 86, 92
 mixing, 43–51 (see also specific color)
 muddy, 43, 60
 picking, 43–49
 pushing, 85
 reflected, 53, 85, 88–89, 91–92
 repetition, 22–23, 49, 74, 77, 86
Composition, 22–23, 28–35, 109, 121–125
Contrast, 21–22, 27, 38, 68, 93, 114
 high, 25, 101
 in photographs, 17–18
Corncobs, 27
Darks, 45, 49–50, 79
 patterns of, 24
 placing, 21, 29

pushing, 79
testing, 27
Depth, 24, 30, 46, 51, 58, 68, 78, 105, 119–120
Detail, 41–42, 67, 96
 drawing, 28–29, 35
 photograph, 17–18, 26
 underwater, 76–77
Drama, 17, 22, 25, 68, 103
Drawing, 11, 28–29, 35, 56, 68, 75, 92
 accuracy, 28, 94, 102, 111, 121
 minimal, 82, 86
Edges, 57, 62–63, 93, 105, 110, 117–118
Effects
 atmospheric, 45, 104
 mottled, 43, 66, 117
Eggs, 23, 82–83
Eye, guiding the, elements for, 30–31, 33, 38
 color, 23, 48, 50
 contrast, 38
 detail, 42, 75
 line, 22, 34, 84
 shadows, 70–71, 82
 shape, 22, 28
 texture, 103
Fabric, 14, 17, 107–110, 119
Flowers, 27, 31, 44, 61, 72, 96–98
 petals, 99–101
 See also specific flower
Focal point. See Center of interest
Fruit, 34, 36–37
 See also specific fruit
Glass
 clear, 19, 25, 30, 55
 colored, 79
 crystal, 34–35, 50, 111–115
 smooth, 92–93
Glow, creating, 41, 54–55, 93, 114
 background, 73
 flower, 67, 100
 by glazing, 58–60, 111
 in grays, 53
 with reds, 46, 86, 123
 wood, 11
 with yellows, 44, 58–59, 75
Gold. See Metals, gold
Golden Mean, 22, 26
Gouache, 14, 102–103, 105
Gradation, 34, 57, 69, 76
Grays, 37, 51–53, 58–59, 91
Greens, 44–45, 97, 124
Hair, 107–110
Harmony, 48, 53, 77, 124
Highlights, 34, 62, 90–91, 105
Hollyhocks, 102–106
India ink, 68

Instruments, musical, 42
Irises, 8, 39, 67, 96–98
Lace, 23–25, 30–31, 36–37, 40, 49, 82–85, 88–89
Leaves, 44–45, 59, 102–106
Light
 color in, 35, 37, 40–41
 manipulating, 24
 patterns, 24
 staging, 35
 temperature, 35, 39, 95
Light, types of
 afternoon, 75
 artificial, 34–35
 back, 25
 bounced, 18, 95
 evening, 64
 front, 25
 glinting, 118
 neon, 42
 reflected, 87, 114, 123
 seasonal, 18
 secondary, 35
 side, 25
 soft, 41
 strong, 32
 sun-, 18, 21, 33–34, 44, 103, 106, 111–115, 118
 See also Glow, creating
Lilies, 29, 32, 63, 67, 74
Line, 22, 34, 84, 90–91
Marbles, 30
Masking, 14, 65, 68, 77, 111, 113, 118
Materials, 12–16
 See also Mediums, mixed; Paper
Mediums, mixed, 67–69
Melon, 80–81, 111–115
Metals, 42, 90–91, 118
 gold, 88–89
 silver, 21, 35, 40, 86–87
Mistakes, 14, 62
 See also Paper, damaged
Necklace, 70–71, 90–91
Onions, 22
Oranges, mixing, 46, 123
Paint chips, 52, 72
Paints, 13, 66, 122
 See also Colors; Pigments
Palettes, color, 13, 43
 limited, 48–49, 53
Paper, 12
 damaged, 62, 103, 115
 handling, 29
Pattern, 23–24, 29, 34, 39
 background, 65
 freehand, 119
 repetition, 70–71